America THE *Beautiful*
FLORIDA

JORDAN WOREK

FIREFLY BOOKS

A FIREFLY BOOK

Published by Firefly Books Ltd. 2010

First printing

Publisher Cataloging-in-Publication Data (U.S.)

Worek, Jordan.
 Florida/ Jordan Worek.
[96] p. : col. photos. ; cm. (America the beautiful)
Summary: A book of captioned photographs that showcase the natural wonders,
dynamic cities, celebrated history and array of activities of Florida.
ISBN-13: 978-1-55407-682-6
ISBN-10: 1-55407-682-X
1. Florida. I. America the beautiful. II. Title.
975.9 dc22 F312.W67 2010

Published in the United States by
Firefly Books (U.S.) Inc.
P.O. Box 1338, Ellicott Station
Buffalo, New York 14205

Published in Canada by
Firefly Books Ltd.
66 Leek Crescent
Richmond Hill, Ontario L4B 1H1

Cover and interior design: Kimberley Young

Printed in China

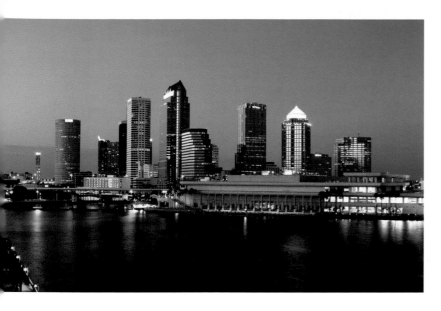

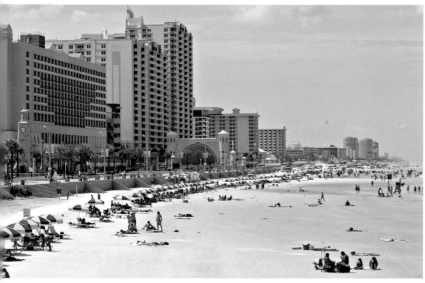

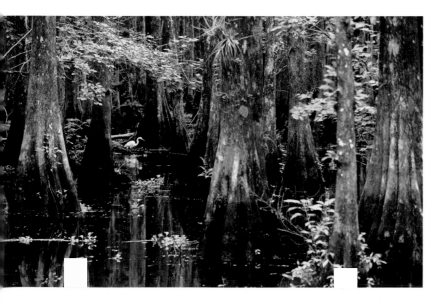

FLORIDA consistently ranks among America's most visited states and has qualities that make for a memorable vacation and an ideal way of life. The more time visitors spend here, the better they understand why this sunny paradise is developing so quickly.

Florida is famous for its sparkling beaches, many of which serve as meeting places for communities. Sun and surf combine to form the backbone of Florida's appeal, drawing spring breakers, vacationing families and celebrities.

Other major draws include, among many others, Walt Disney World, Universal Studios, Busch Gardens and SeaWorld. The golf courses that pepper the state provide a quieter escape for countless enthusiasts.

For those who love speed and adventure, Florida can provide something nowhere else on Earth can – the home of the Daytona 500 *and* the gateway to the skies. The crowds, the noise, the smells, the displays – they're all part of the NASCAR experience. If you prefer to go up instead of around, the Kennedy Space Center has been the liftoff point for some of the nation's greatest successes.

Florida's biggest cities, Miami, Tampa and Jacksonville, offer world-class museums and art galleries along with designer stores, trendy nightclubs and an array of restaurants. Many people who love cities, however, also appreciate the awe-inspiring plant and wildlife that fill the Everglades.

Despite its modern image, Florida also appeals to history buffs. St. Augustine, founded in 1565, is the earliest continuously occupied European settlement in the country. Antebellum plantation homes and live oaks draped in Spanish moss are favorite Florida sights, as are the 19th-century lighthouses that dot the coast. You can find plenty of Art Deco in South Beach, but don't forget about the grandeur of the state's period hotels such as the Breakers, and the mansions of Ringling and Deering.

The Sunshine State is a place of great activities, thriving cities and outstanding natural beauty – and the setting for all sorts of hidden treasures. We hope you agree once you travel the pages of *America the Beautiful – Florida*.

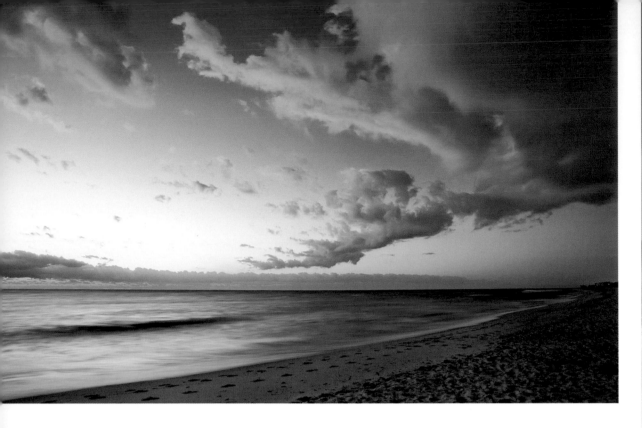

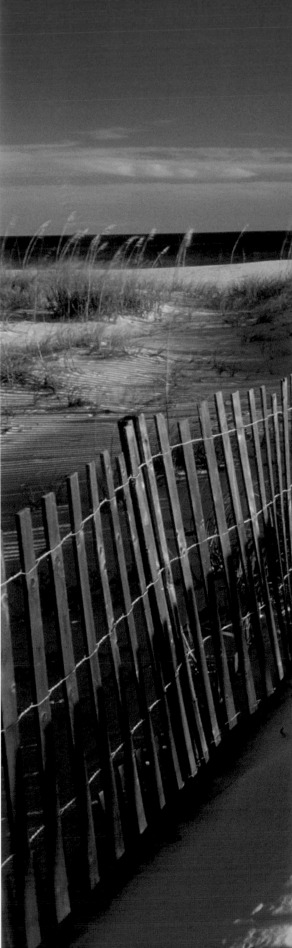

The beach is to Florida what the town square is to most towns, and whether it's packed with bathers or deserted during a long sunset, there's something magical about the place. Florida is blessed with sparkling beaches and well deserves it nickname, the "Sunshine State."

OPPOSITE PAGE: Santa Rosa Island, the longest barrier island in the Florida Panhandle, is just 30 miles east of the Alabama border. Parts of the island are in the Gulf Islands National Seashore.

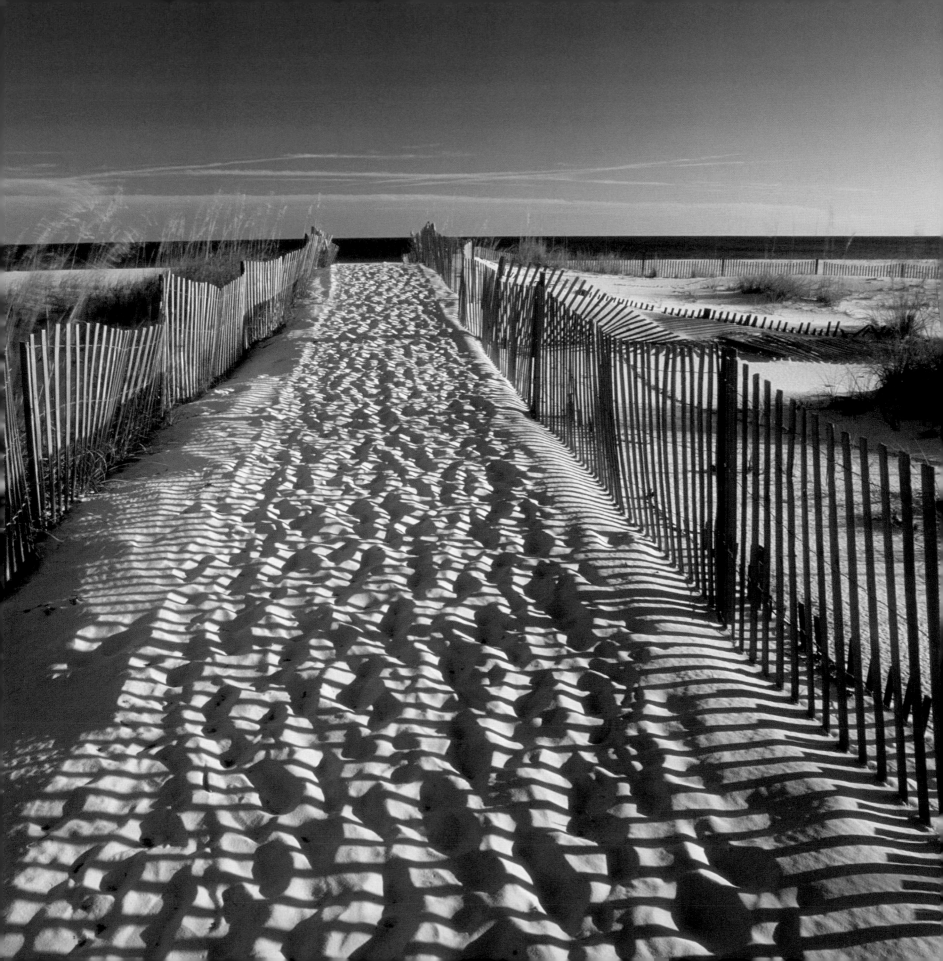

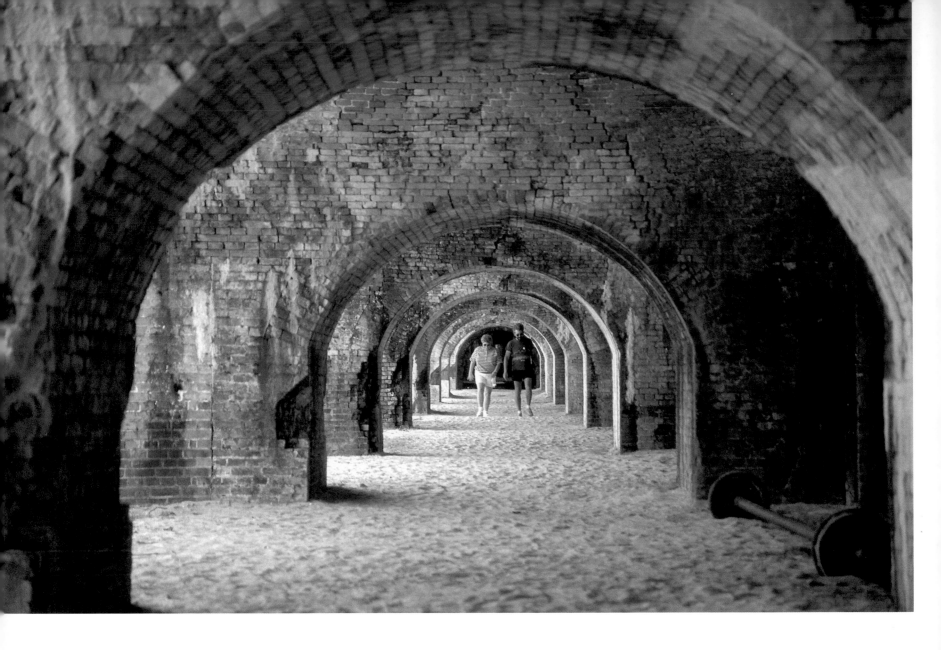

Fort Pickens on Santa Rosa Island was completed in 1834 and in use until 1947. Unlike most examples of early American defensive structures, Fort Pickens adapted to the times and 10 different gun batteries were installed between the 1890s and 1940s. After the Second World War, the fort was obsolete and in 1976 was opened to the public.

OPPOSITE PAGE: Florida Caverns State Park, located in the Panhandle near Marianna, offers cave tours to the public. This illuminated room provides a panoramic view of the stunningly beautiful stalactites, stalagmites and other fragile formations formed over tens of thousands of years.

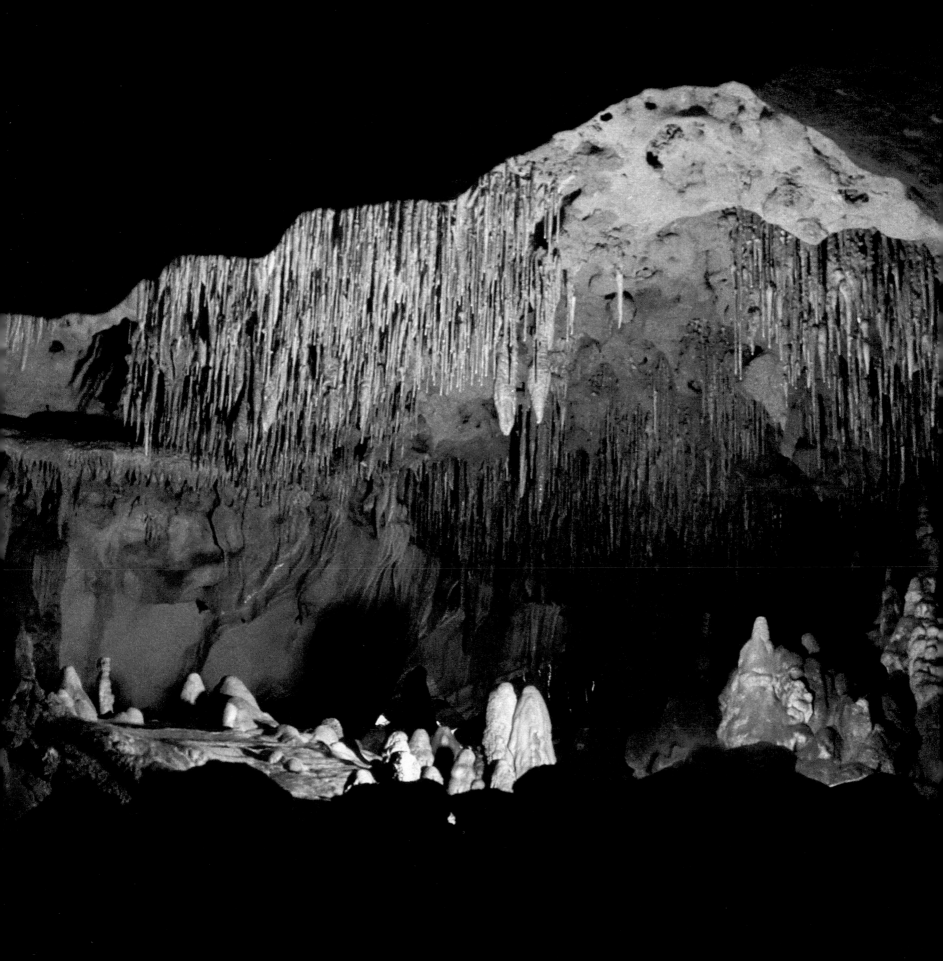

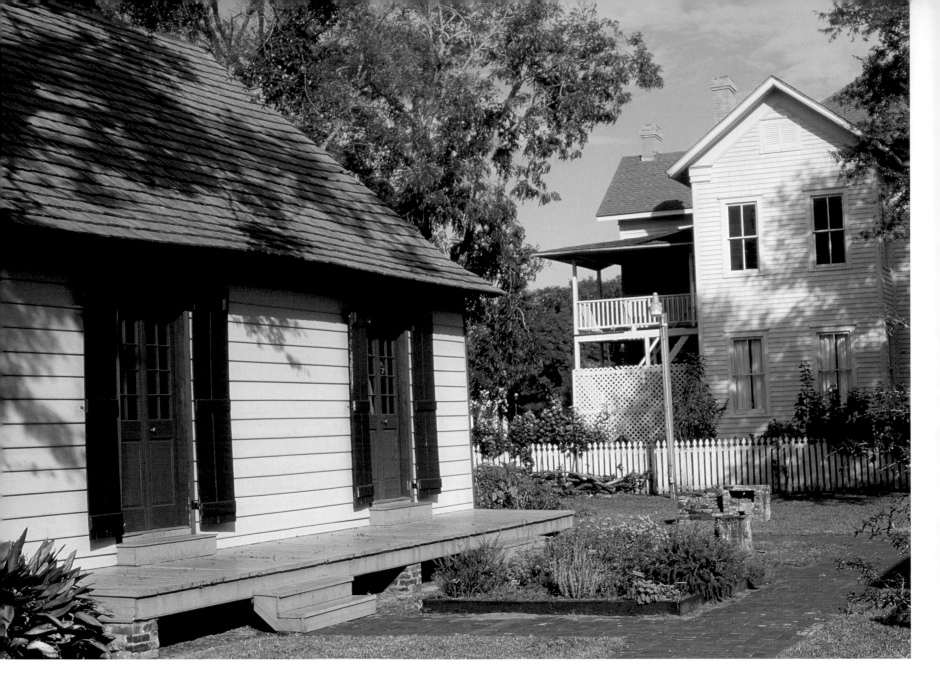

This French Creole-style house was built for Charles Lavalle in 1805 and is now one of 27 structures in the Historic Pensacola Village operated by the University of West Florida. The village is open to the public and includes several museums.

Pensacola has a rich history going back 450 years and is known as "The City of Five Flags" because of the five different nations that have flown their colors here. Historic buildings with characteristic wrought-iron balconies grace the Seville District and Pensacola has several well-known historical organizations to keep that history alive.

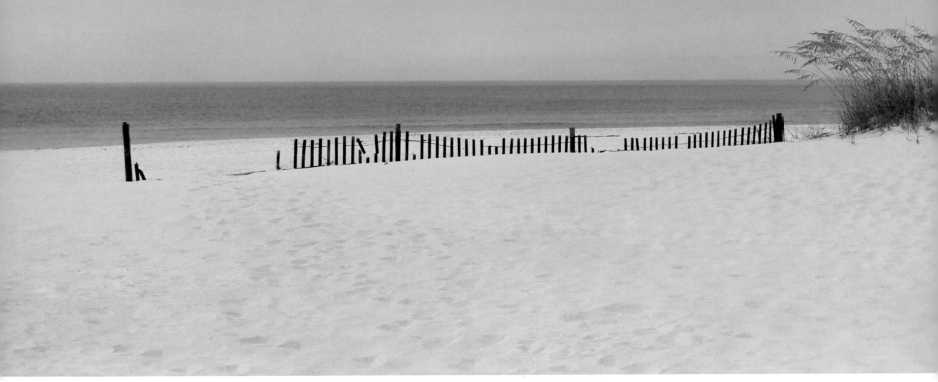

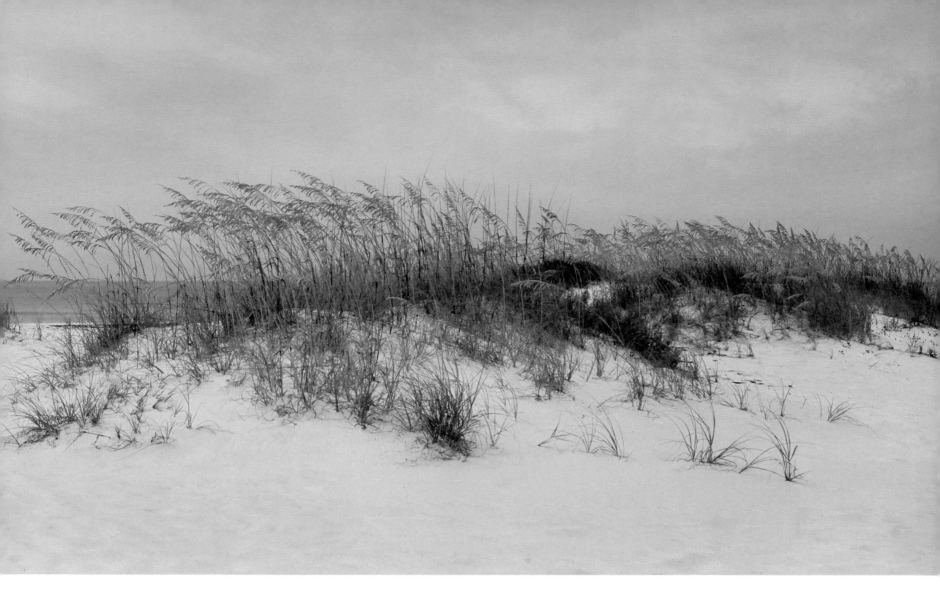

Beaches are beautiful but can also be very delicate. Besides protecting sea life and monitoring water quality, coastal communities must also maintain their system of sand dunes. *Ammophila* is the genus of the grasses we commonly refer to today as marram, bent or beach grass. The roots of these plants anchor the dunes and protect them from erosion by wind and water.

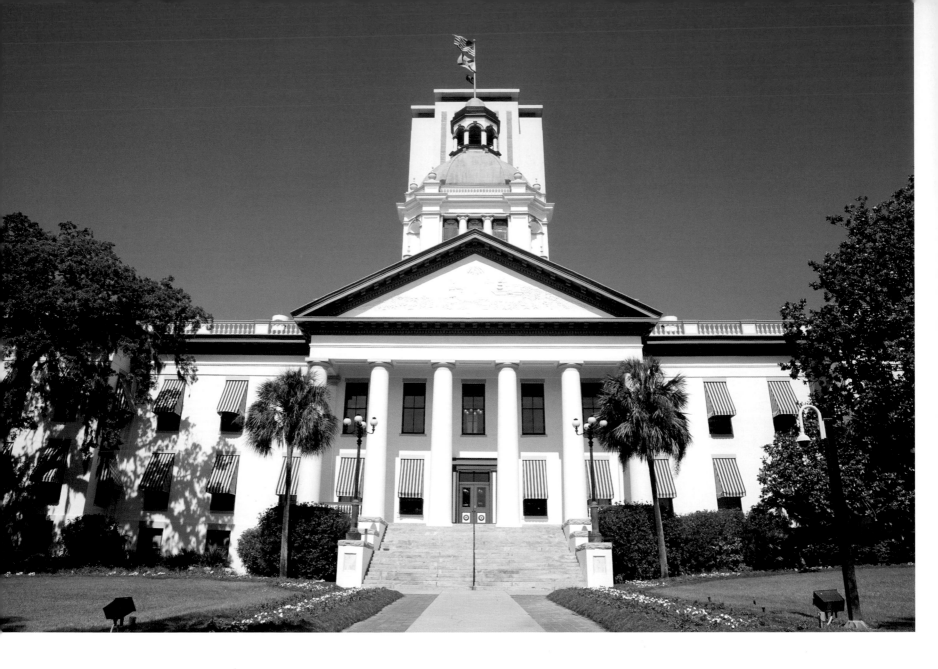

In 1824, Tallahassee was selected as Florida's capital because it lay about midway between the state's two other major cities, St. Augustine and Pensacola. Tallahassee was the only Confederate capital east of the Mississippi not captured by Union forces, and it still offers plenty of Southern charm. The Greek Revival Old Capitol building was completed in 1845; its 22-story replacement towers in the background.

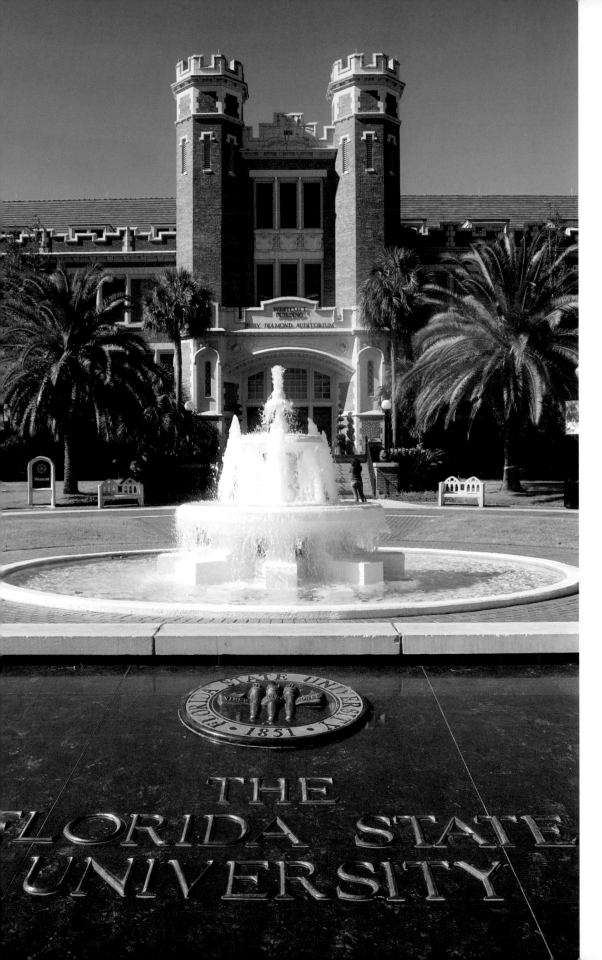

Florida State University is located in Tallahassee. Since being established in 1851, it has continued to expand in size and prestige. Today, nearly 40,000 students attend the school. The Westcott Building shown here was built in 1909.

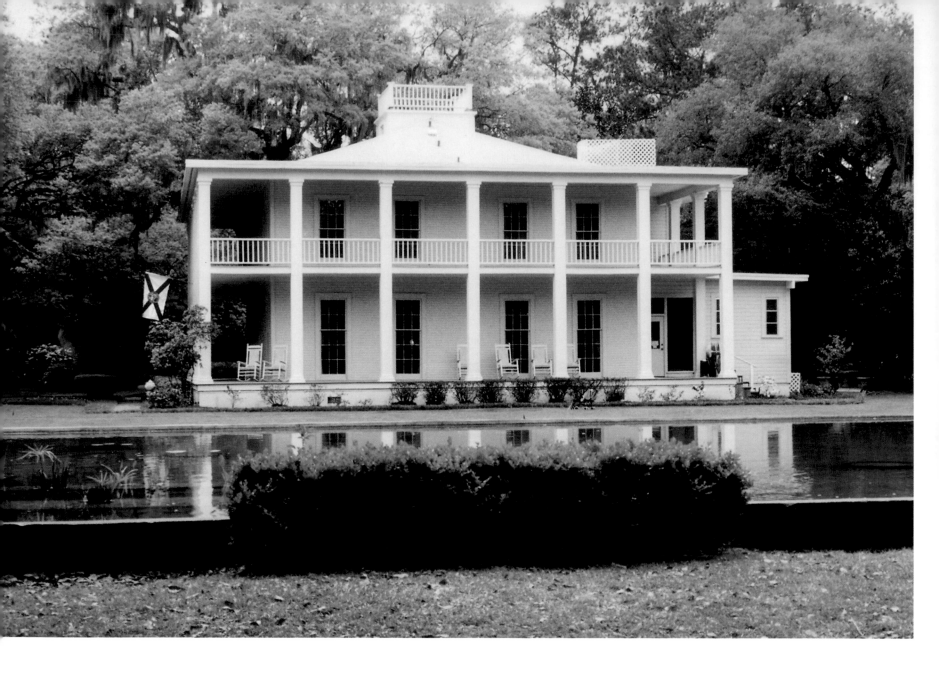

Majestic Antebellum plantation homes were once found across Florida and the rest of the South. The majority of plantations in the state produced rice, sugar or cotton in their heyday, but most of those remaining now function as museums or private homes.

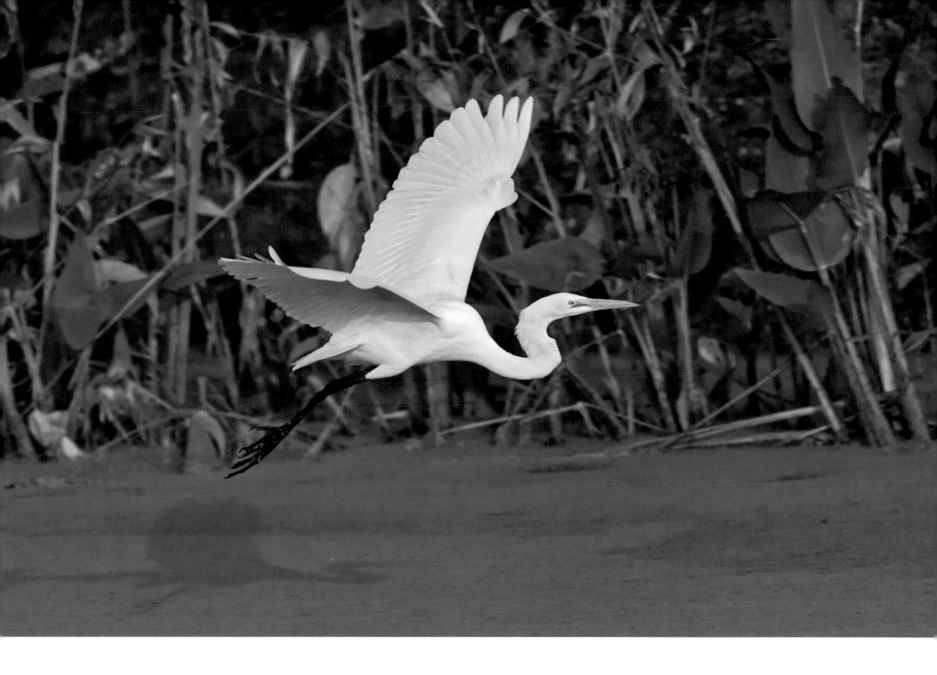

The great white egret, one of Florida's most dramatic bird species, can stand three-and-a-half feet tall. Large numbers of egrets were killed in the late nineteenth century for their snow white plumage, which was used to decorate hats. Today, their biggest threat is loss of habitat.

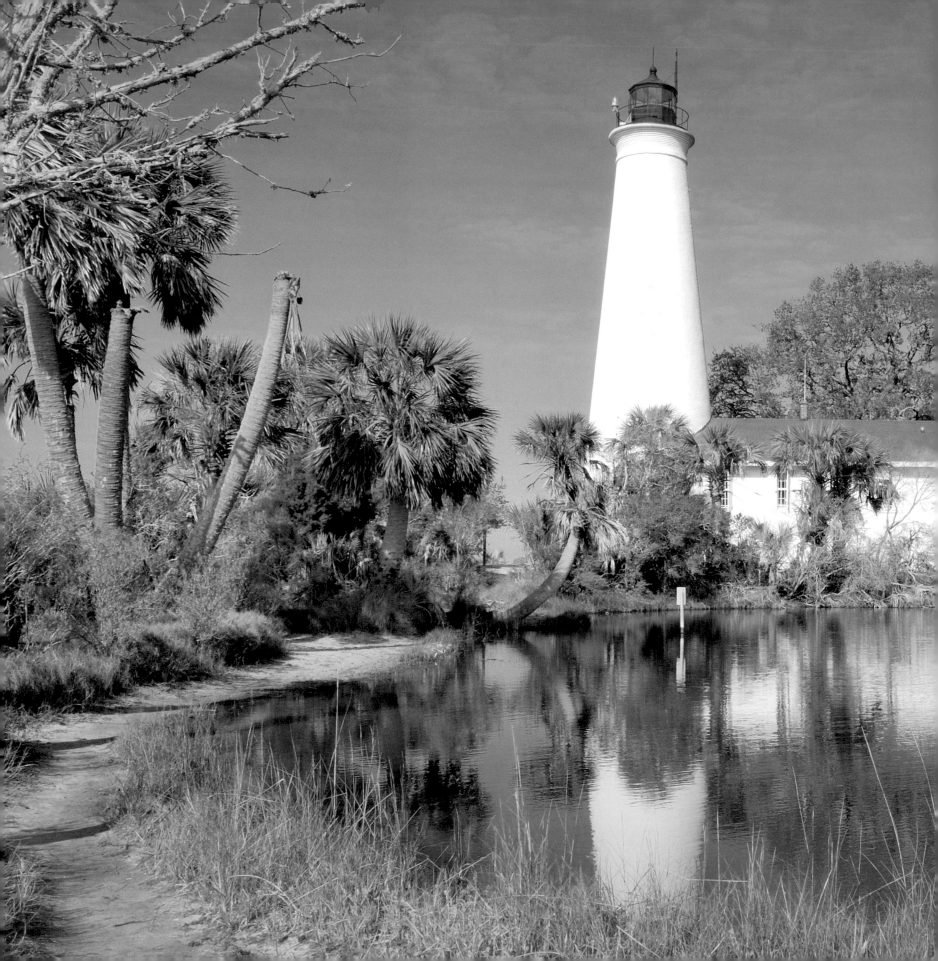

By the 1820s, the town of St. Marks was an important port and served the prosperous planting regions of middle Florida. Congress authorized funds for a lighthouse, which was completed in 1831. But erosion soon threatened the structure, and it had to be dismantled and moved farther inland. The lighthouse suffered damage during the Civil War and underwent extensive reconstruction.

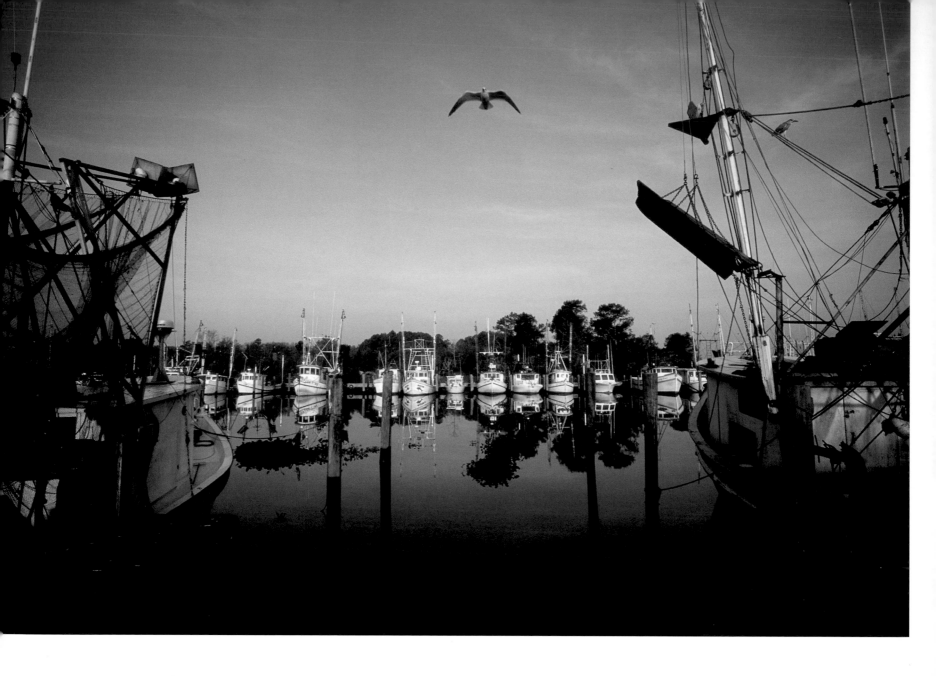

Apalachicola Bay, an estuary on the northwest coast of Florida, is famous for its harvests of oysters and shrimp. Rows of shrimping boats line the harbor, and many locals catch their own shrimp. Most tourists, however, enjoy their shrimp at one of many seafood restaurants.

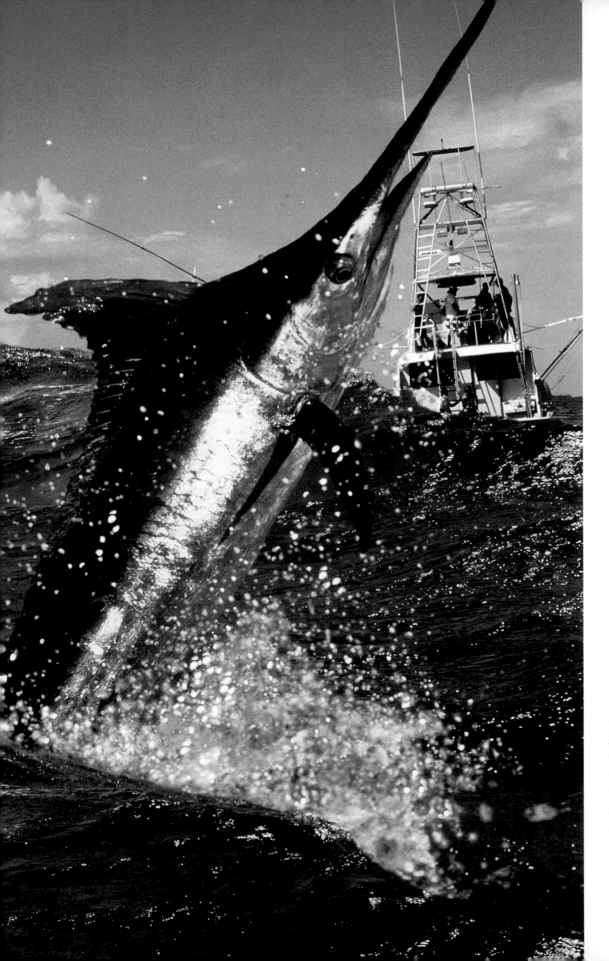

A large blue marlin with its spear-like snout jumps out of the water to the delight of eager fishermen. These impressive creatures can grow to lengths of nearly 15 feet and weigh more than 1,500 pounds. Fishing is a favorite recreational activity in Florida and an important commercial operation in many coastal areas.

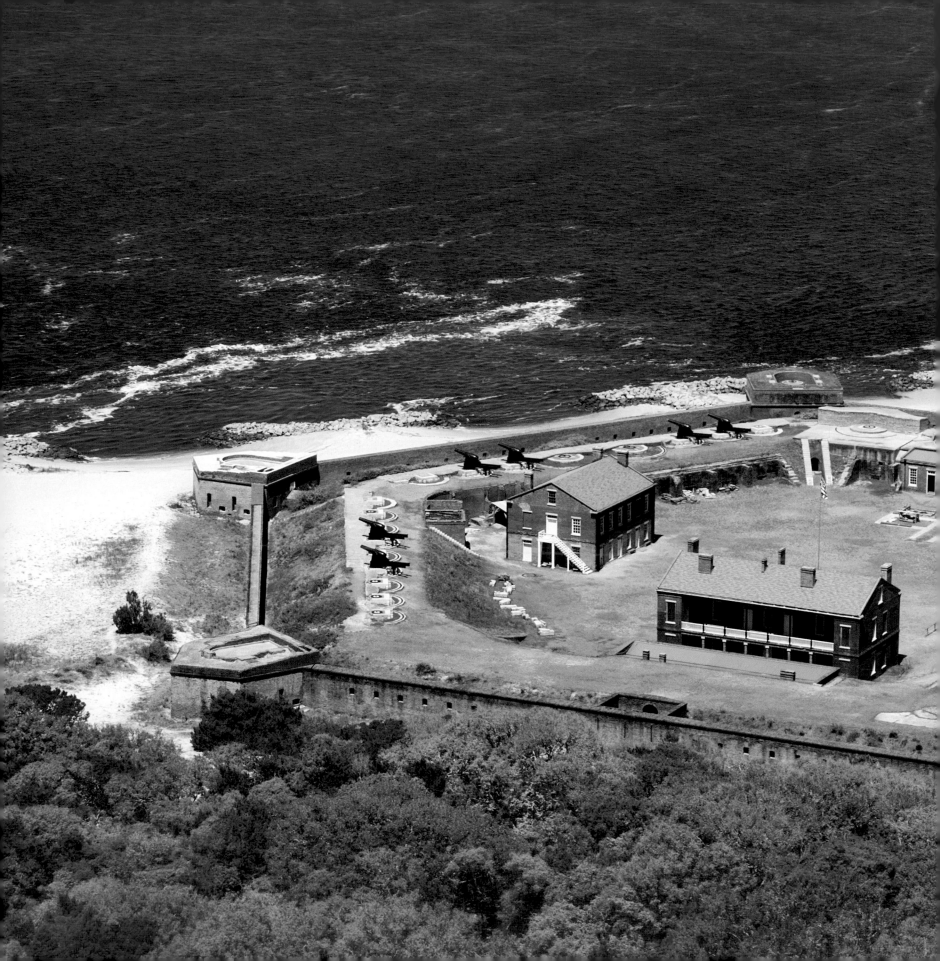

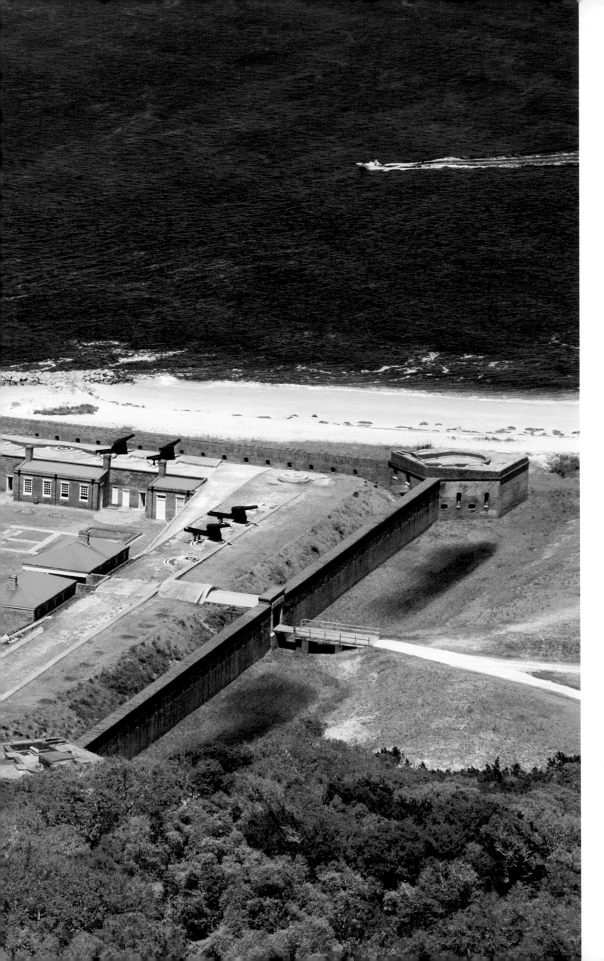

Fort Clinch State Park has been a part of the park systems since 1935. The fort is one of the best-preserved defensive structures in the nation. The site has been occupied by military troops since at least 1736, but work began on the familiar pentagonal walls in 1847. Five million bricks were used to build the fort complex.

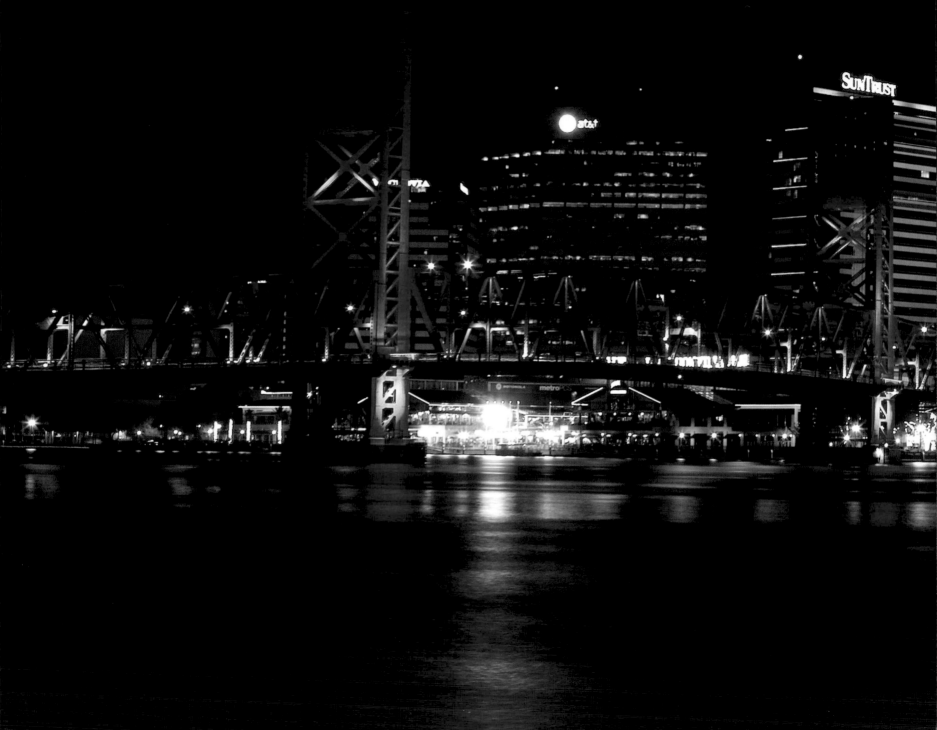

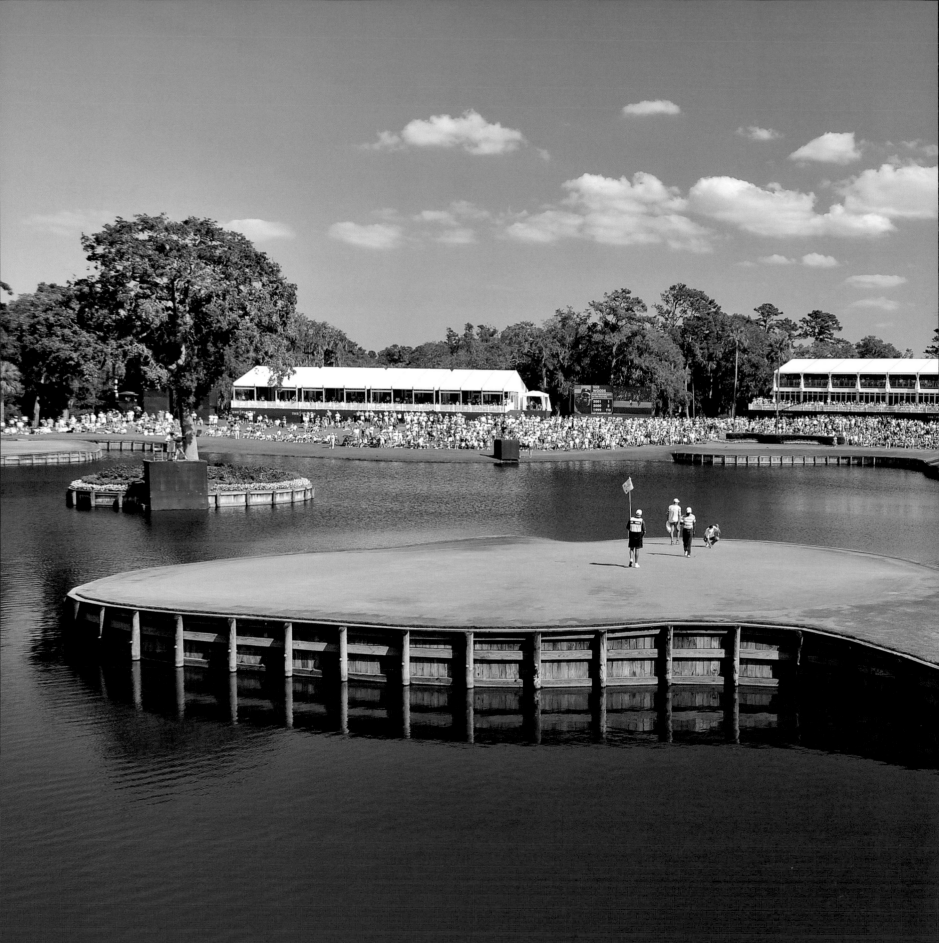

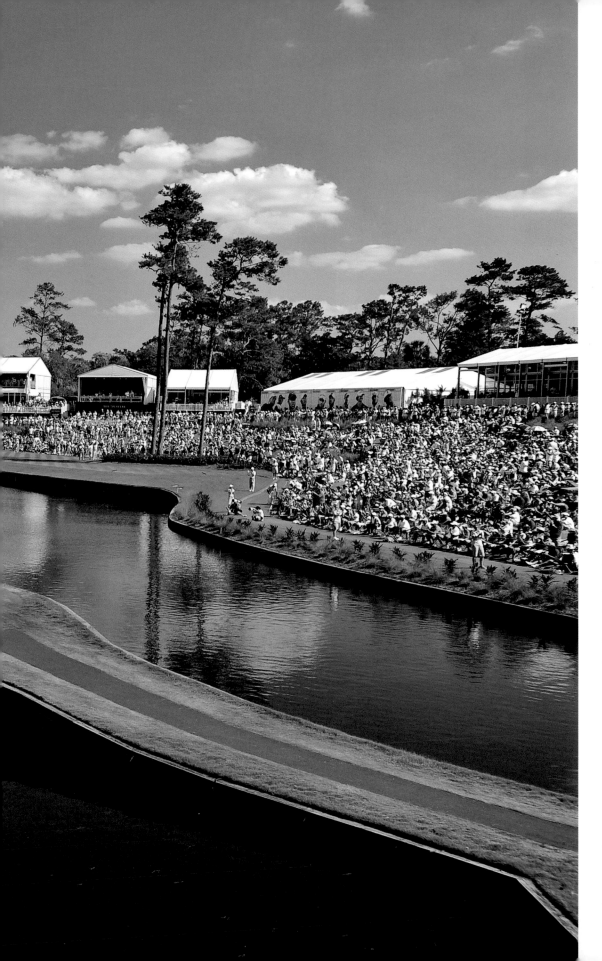

The groundbreaking ceremony for the TPC Sawgrass golf course occurred on February 12, 1979, on what was then little more than Ponte Vedra Beach marshland. The following year the course, designed by Pete and Alice Dye, opened to critical acclaim. It has since become one of the most famous – and among the toughest – courses in the world. Sawgrass is home to The Players Championship, the PGA Tour's flagship event.

PREVIOUS PAGE: Although once known for its paper mills, Jacksonville has transformed itself in recent years and is now a center for insurance and banking. Earlier known as Cowford because cattle crossed the St. Johns River here, the city was renamed in 1822 to honor Andrew Jackson, who had forced Spain to cede Florida to the United States three years earlier.

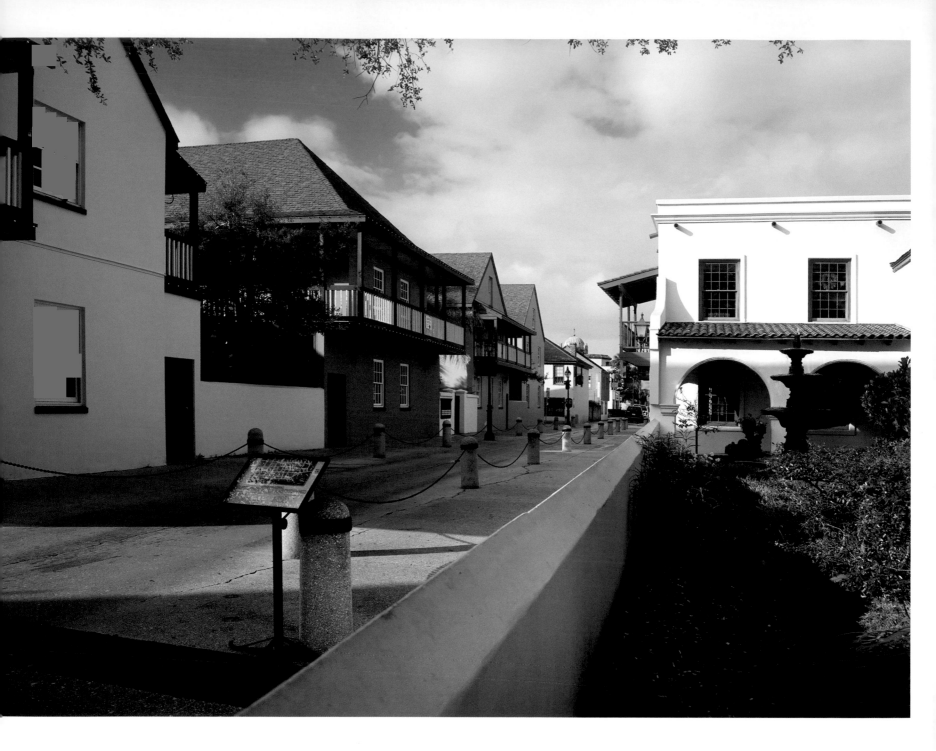

Hypolita Street, in the heart of St. Augustine's historic district, is surrounded by bakeries, galleries, quaint shops, and bed and breakfasts. With its Spanish-style architecture, Old World charm and panoramic bay, it's easy to see why the city attracts so many visitors.

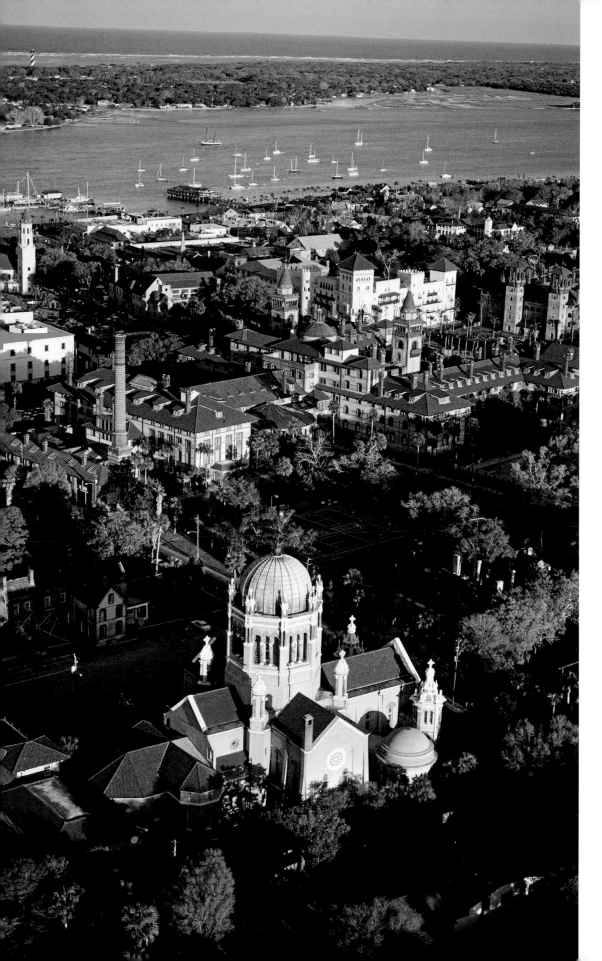

Beautiful St. Augustine is the oldest continuously occupied European-established city and the oldest port in the continental United States. The Ponce de Leon Hotel, the large complex in the center of the photograph, was completed in 1887 and named after the explorer who first came here in 1513. Today it is Flagler College. The Flagler Memorial Presbyterian Church rises in the foreground.

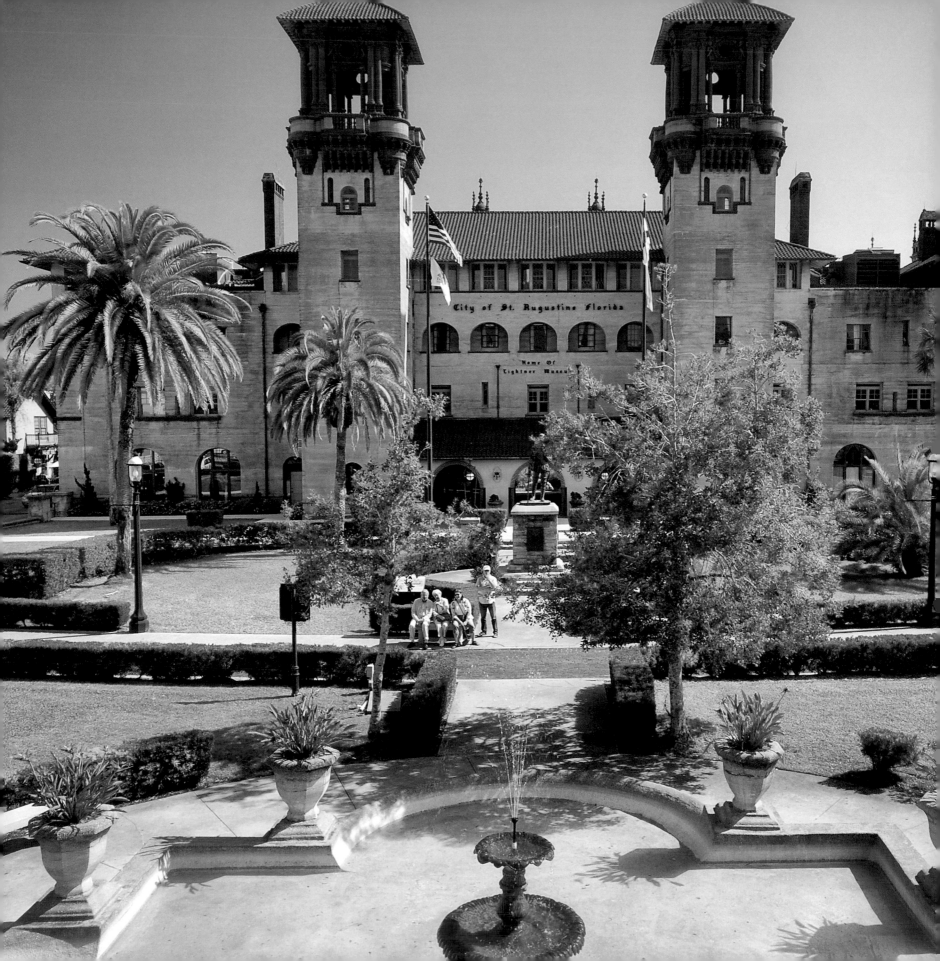

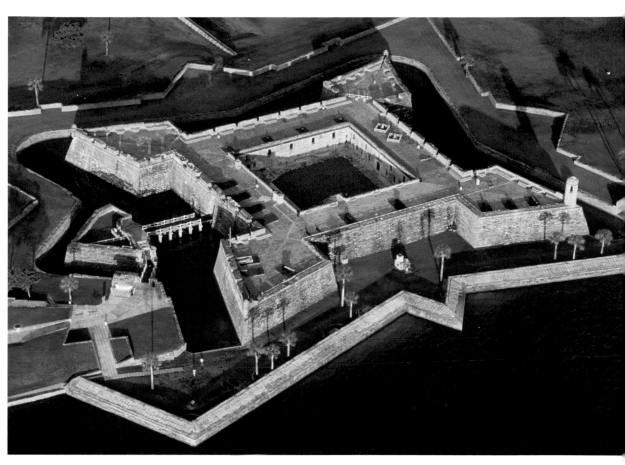

ABOVE: Work began on what is now known as the Castillo de San Marcos National Monument in October 1672. The masonry fortifications were designed to replace the wooden forts that had defended the city previously. The Castillo resisted a two-month siege by the British in 1702, when the entire population of St. Augustine remained safe behind its walls.

LEFT: The Lightner Museum in St. Augustine is housed in the former Hotel Alcazar, commissioned by railroad magnate Henry Flagler and completed by architects Carrere and Hastings in 1887. The Chicago publisher Otto Lightner purchased the structure in 1946 to house his collection of Victoriana. Two years later the museum opened to the public.

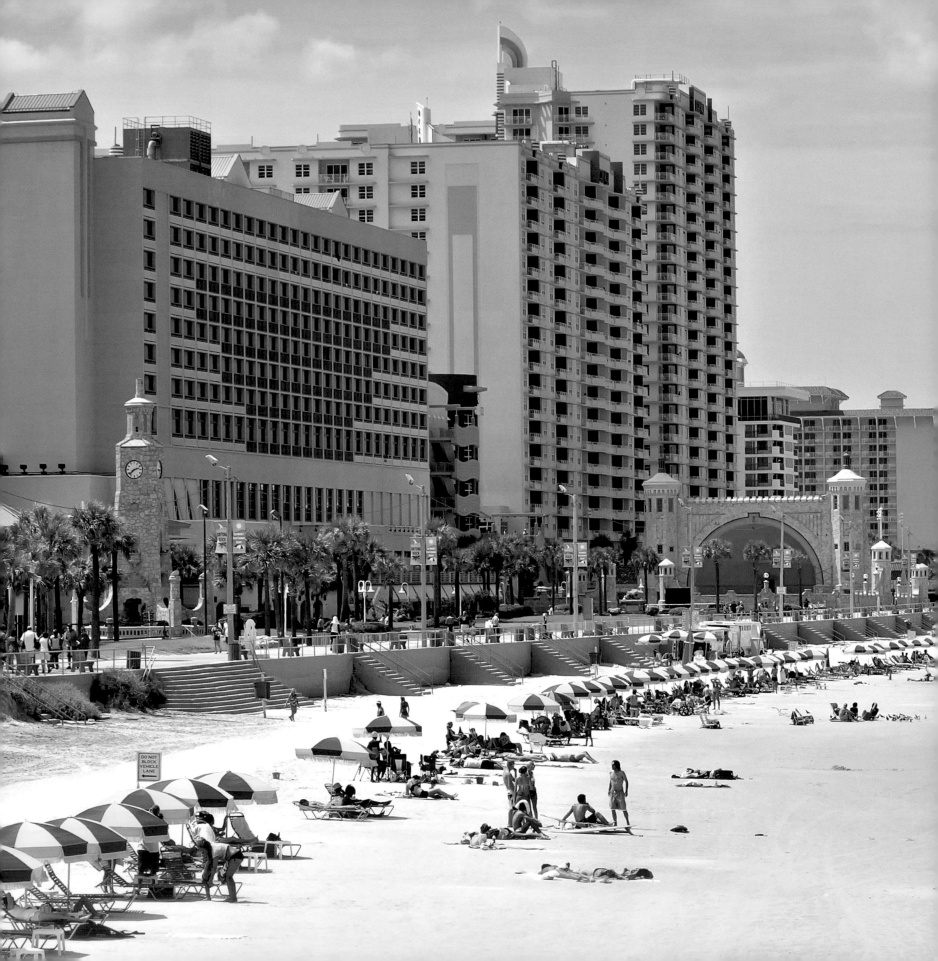

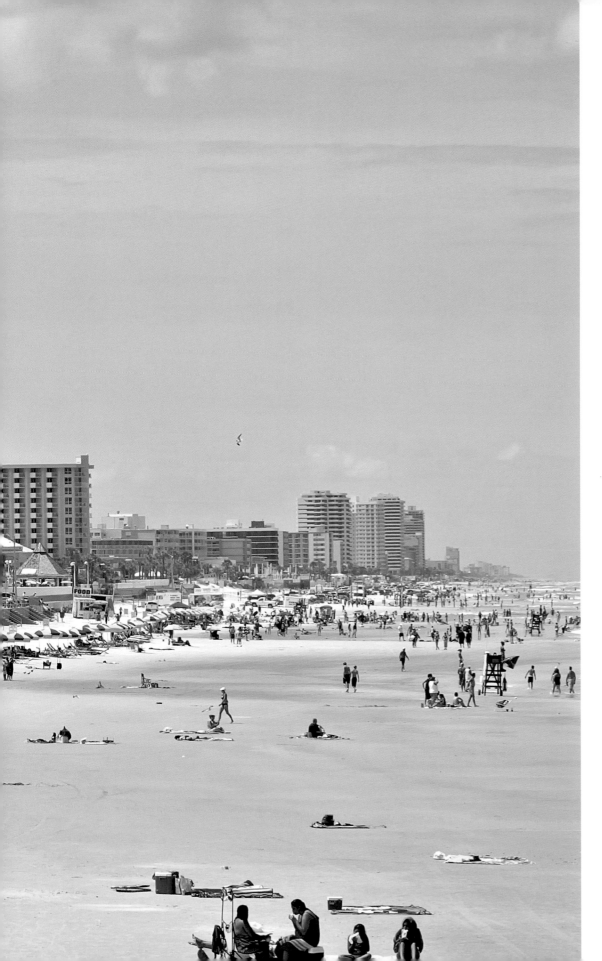

Daytona Beach is famous for its beautiful white sand beaches and has a surprisingly good art museum. If you visit during Speed Weeks in early February, however, the city may seem a little crowded; 200,000 fans flock to the Daytona International Speedway to watch the cars in action.

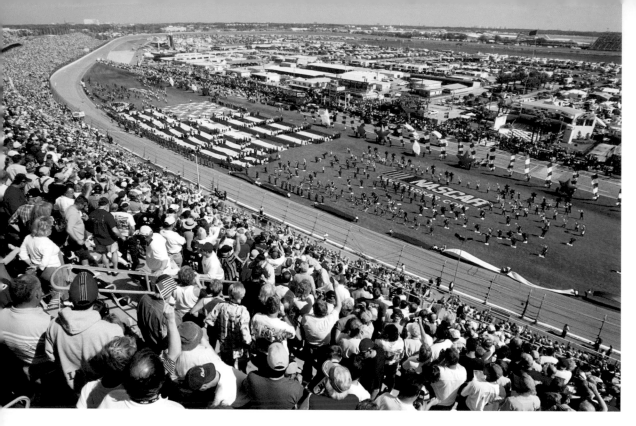

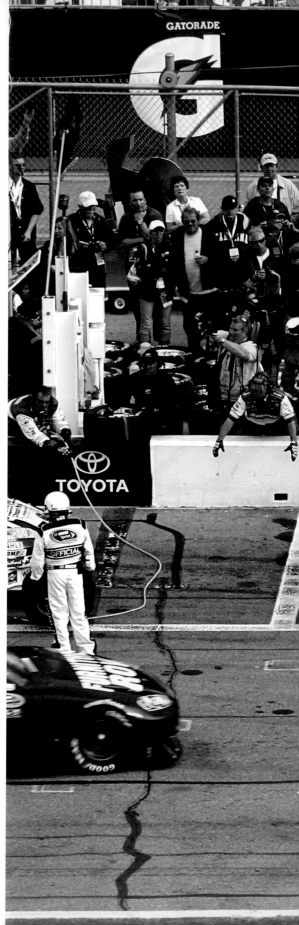

ABOVE: The crowds, the noise, the smells, the displays – they're all part of the NASCAR experience, and fans love every minute of it. The city's balmy climate lends itself to the hosting of Speedweeks and the Rolex 24 at Daytona, the unofficial start of the racing year in February.

RIGHT: The International Speedway opened in 1959 and is the much-loved home of NASCAR, drawing countless loyal fans to Daytona every year. The busiest place on the speedway is always the pit, where a driver's crew can change four tires and refuel in 12 seconds flat.

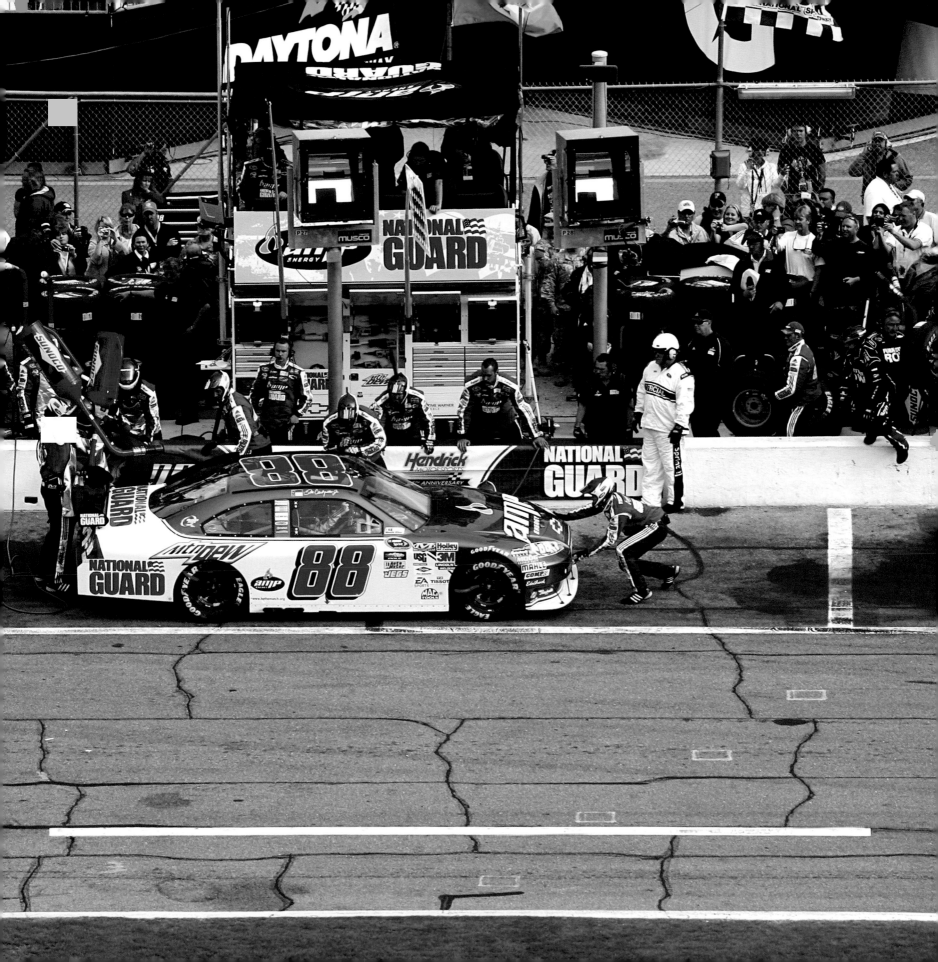

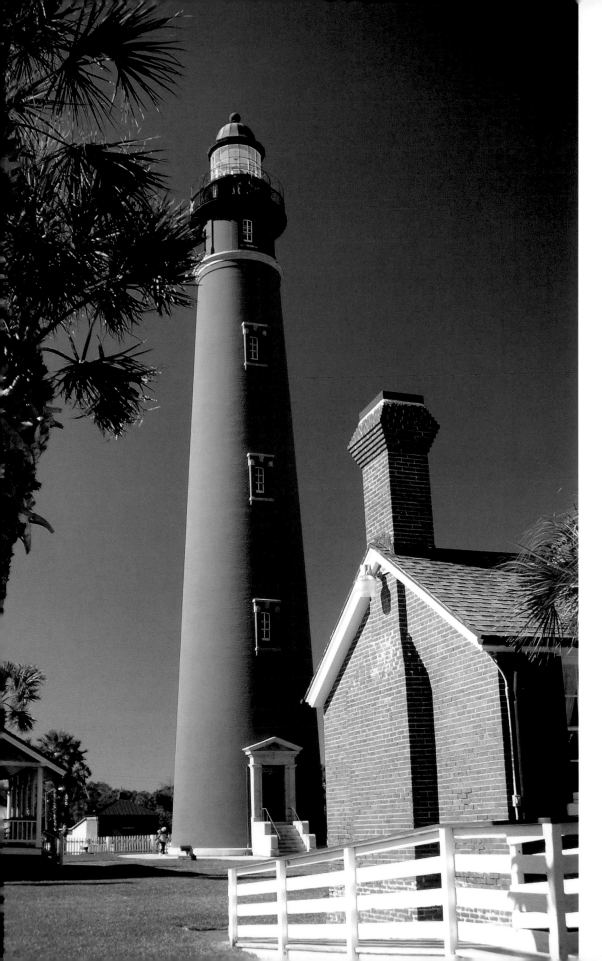

OPPOSITE PAGE AND LEFT: The current Ponce de Leon Inlet Lighthouse and Museum is, at 175 feet, the tallest lighthouse in the state and one of the tallest in the country. The original structure was erected in 1835, but storms soon weakened the foundations and it was further damaged during the Second Seminole War.

After the collapse of the original structure, there was no workable lighthouse here until 1887, when the new tower was completed. The oil lamp was replaced in 1909 with an incandescent lamp, and the lighthouse was electrified in 1933. The Coast Guard deeded the property to the Town of Ponce Inlet in 1972.

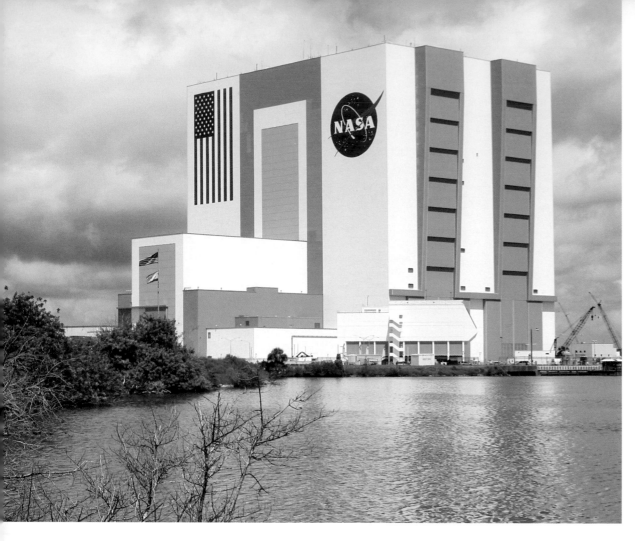

ABOVE: The Vehicle Assembly Building is the fourth largest building in the world by volume and was originally used to assemble the Saturn V rocket for the Apollo Program. The stars on the American flag painted on the south side are an astonishing six feet in diameter, and the stripes are nine feet wide.

RIGHT: The Kennedy Space Center on Merritt Island manages America's astronaut launch facilities and has been the liftoff point for some of the nation's greatest successes and tragedies. The enormous complex began to take shape in 1958 and it continues to adapt to meet the changing needs of today.

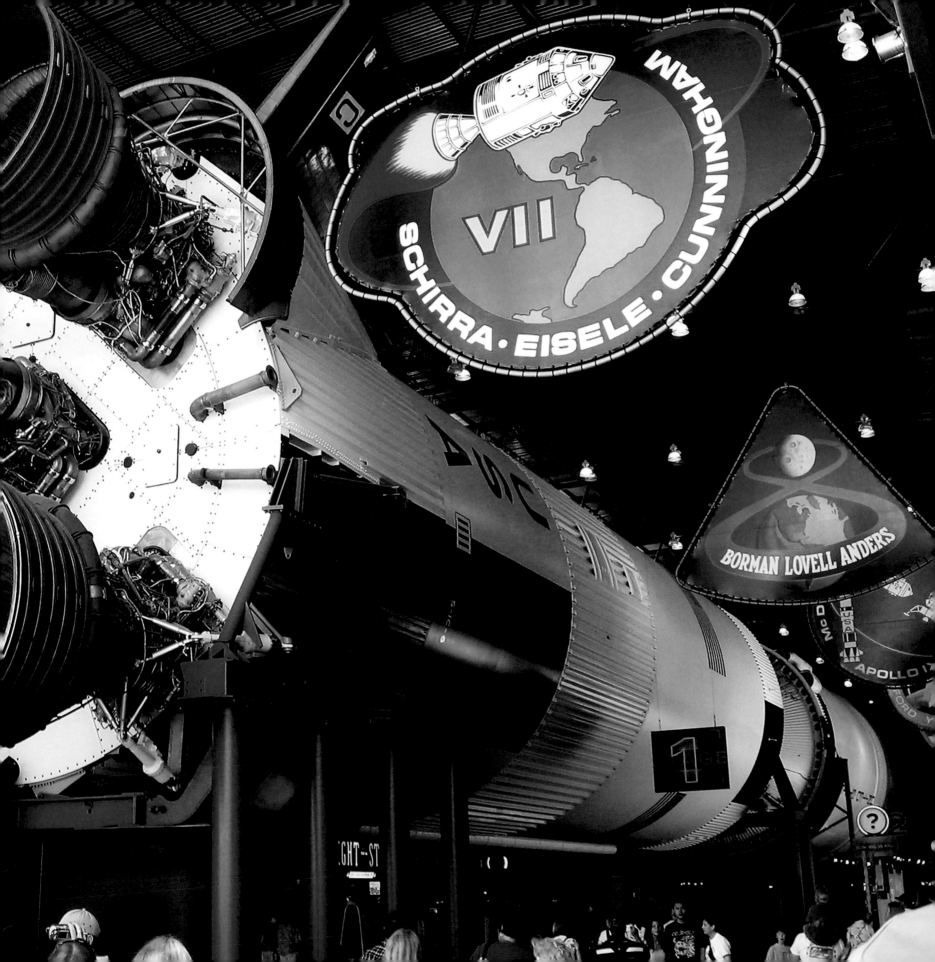

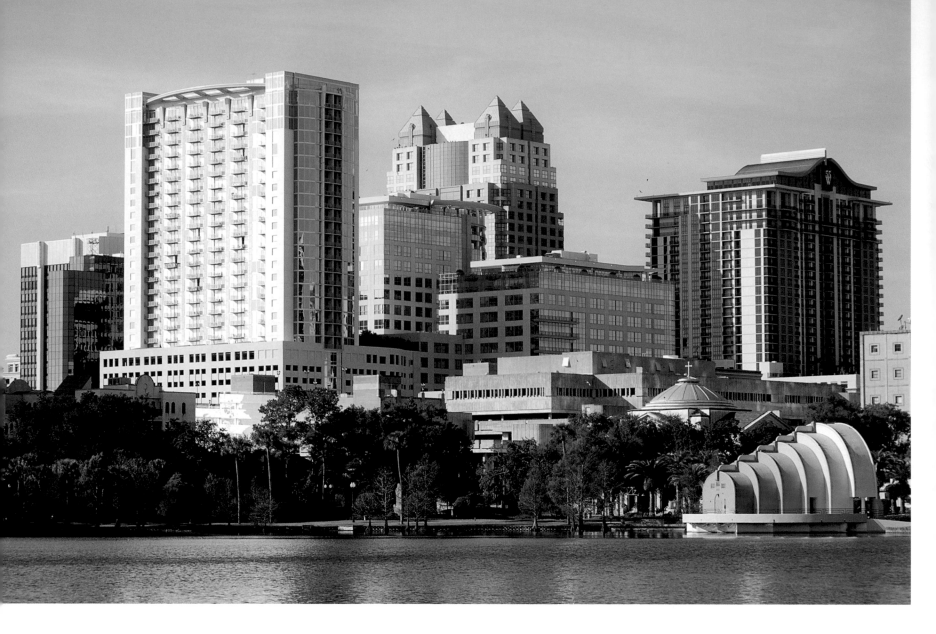

The sparkling towers of modern Orlando rise above the waters of Lake Eola. The fifth largest city in the state, Orlando is constantly growing and rapidly developing into a major center for the technology industries. Tourism, however, is still its economic anchor. There are more than 115,000 hotel rooms in the city, with hundreds or thousands more being added each year.

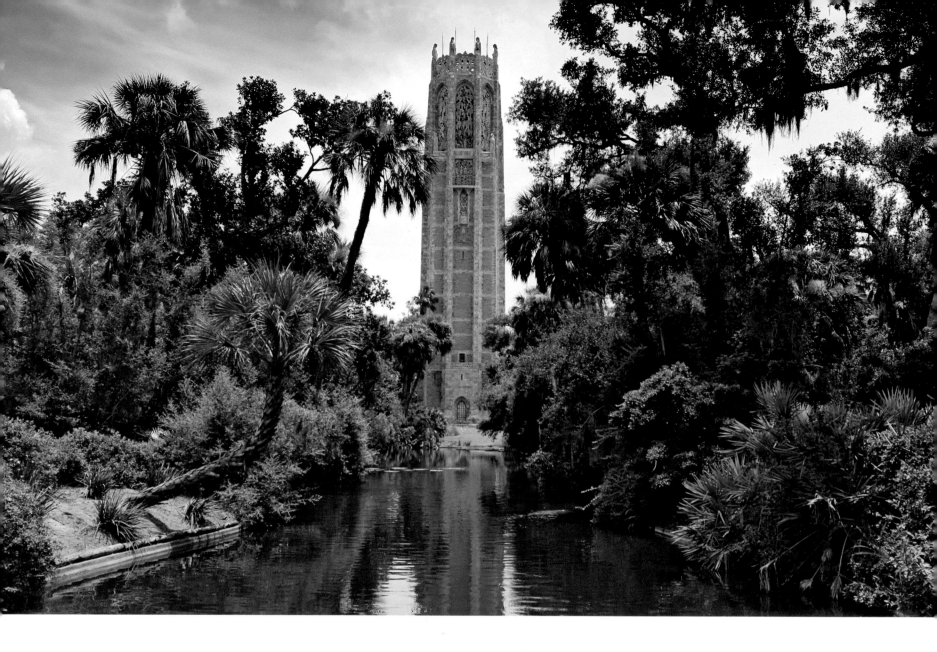

Bok Tower Gardens is a National Historic Landmark north of Lake Wales. The massive project of developing the gardens was begun by Edward Bok, editor of *Ladies Home Journal*, in 1921. On February 1, 1929, President Calvin Coolidge dedicated the neo-Gothic Singing Tower carillon – one of the world's great carillons, with 60 bronze bells.

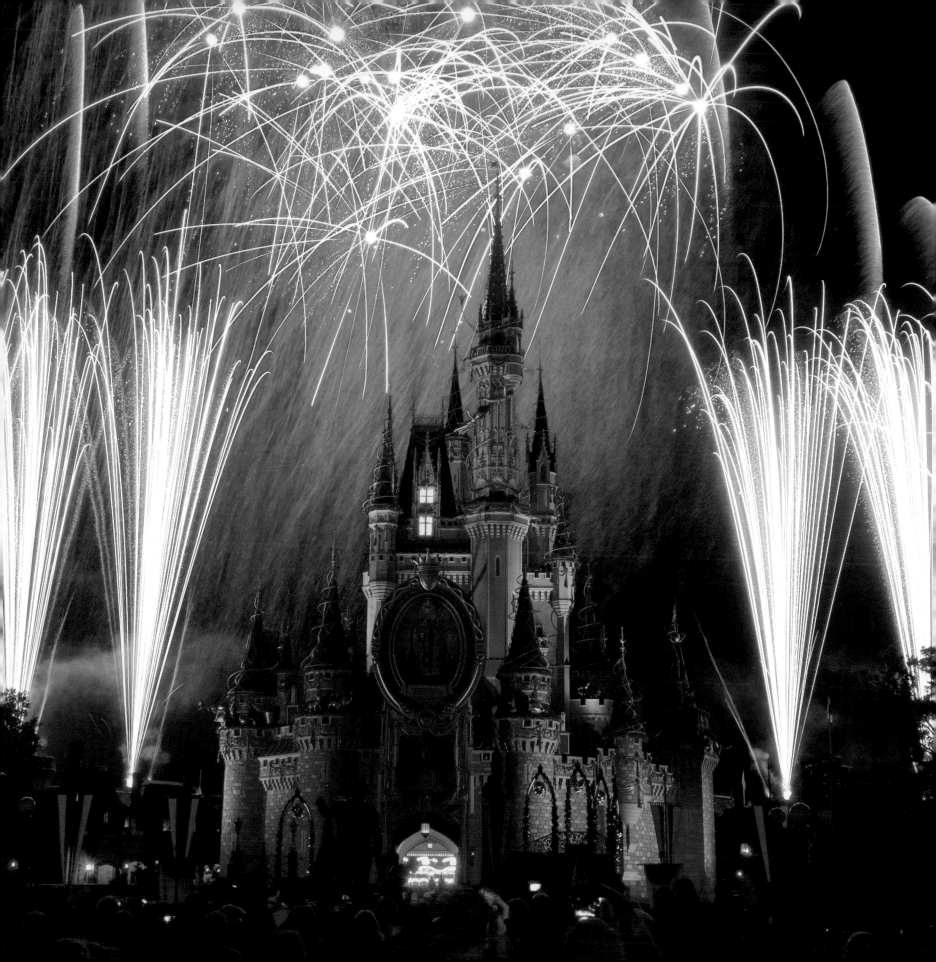

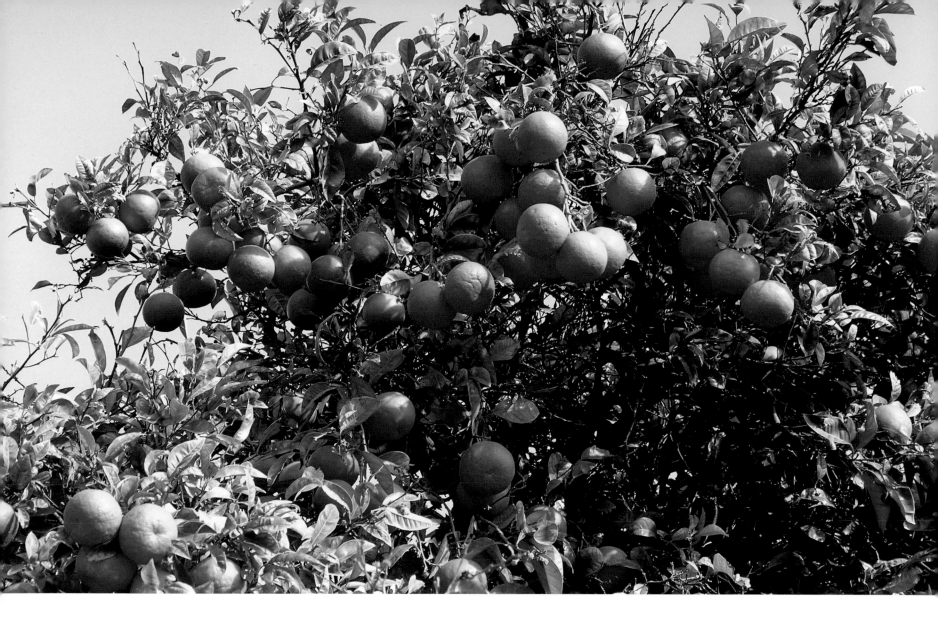

Florida grows more oranges than any other state and is the second largest producer in the world after Brazil. This delicious fruit needs a stable, sunny climate between 60°F and 85°F, making Florida an ideal location. Commercial orange groves began to spring up in the late 1800s as railroad links to major northern cities made growing oranges financially profitable.

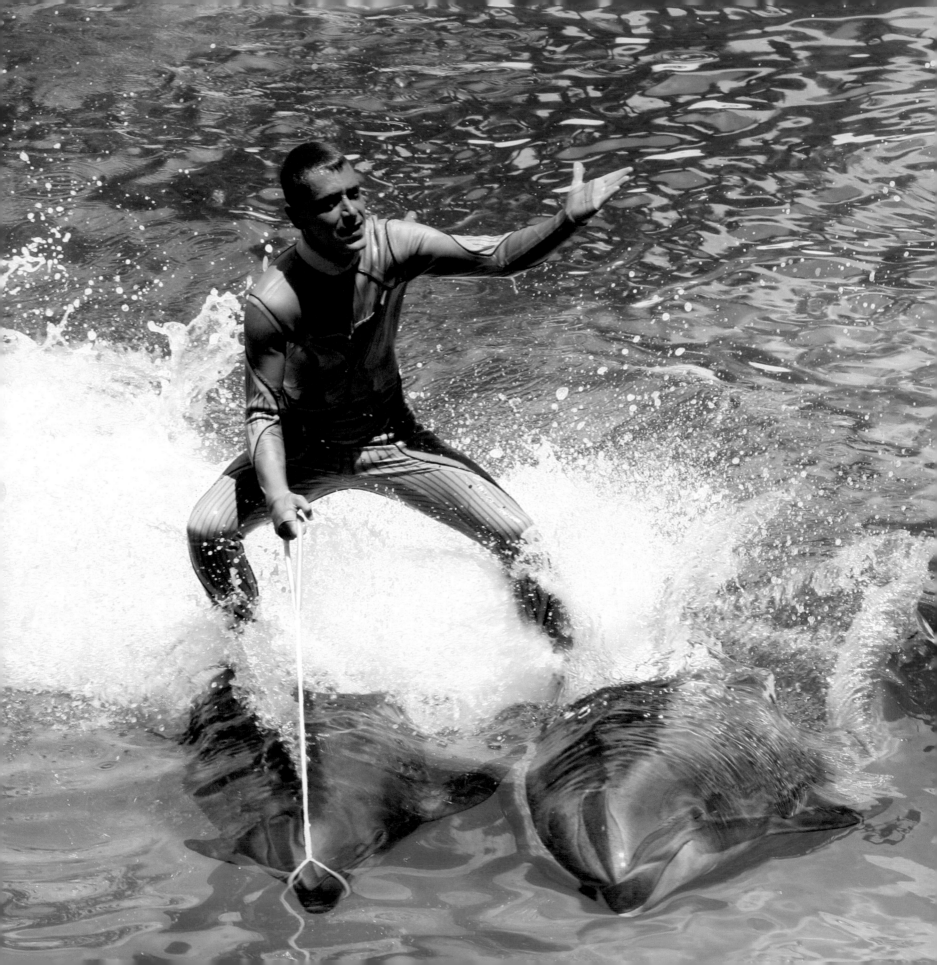

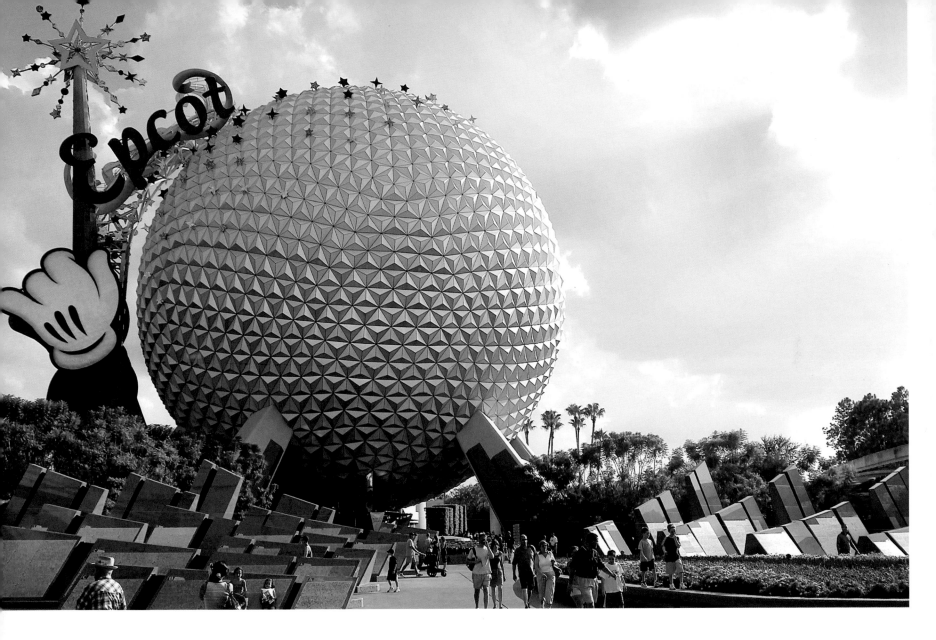

Spaceship Earth is the icon of Epcot, the second theme park built at Walt Disney World Resort. First opening its doors in 1982, Epcot (which stands for Experimental Prototype Community of Tomorrow) is dedicated to international culture and technological innovation.

OPPOSITE PAGE: SeaWorld Orlando is one of the country's most visited theme parks and, combined with its neighbors Discovery Cove and Aquatica water park, forms one of the largest entertainment complexes devoted to ocean life. Some of the most popular residents at SeaWorld are dolphins. Approximately six million visitors come here every year.

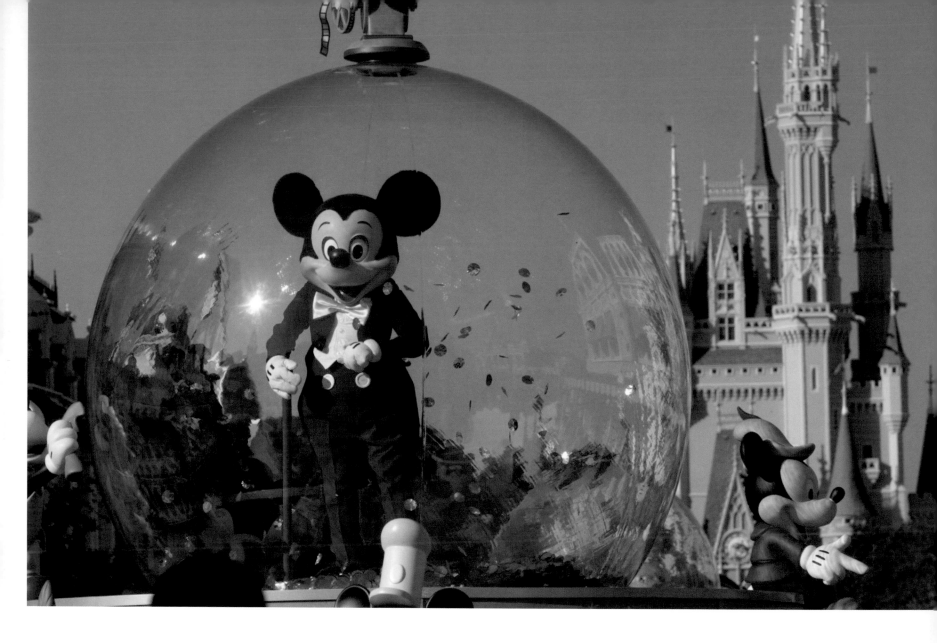

OPPOSITE PAGE AND ABOVE: When Walt Disney World opened its doors 40 years ago, no one, not even Walt himself, could ever have imagined how it would lead to the transformation of the entire area. Although Disney World is always reinventing itself, Cinderella Castle and Mickey Mouse remain some of the most iconic images that have deeply imprinted themselves on the American mind.

Kissimmee (with the accent on the second syllable), in the heart of the state, was incorporated as a city in 1883. The peaceful beauty of the surrounding area charms residents and visitors alike.

FOLLOWING PAGE: The Sunshine Skyway Bridge stretches five-and-a-half miles across Tampa Bay and is built of prefabricated concrete with steel supports. Construction was completed in 1987, replacing the original 1950s bridge, which was partially destroyed when the freighter MV *Summit Venture* collided with a pier during a storm.

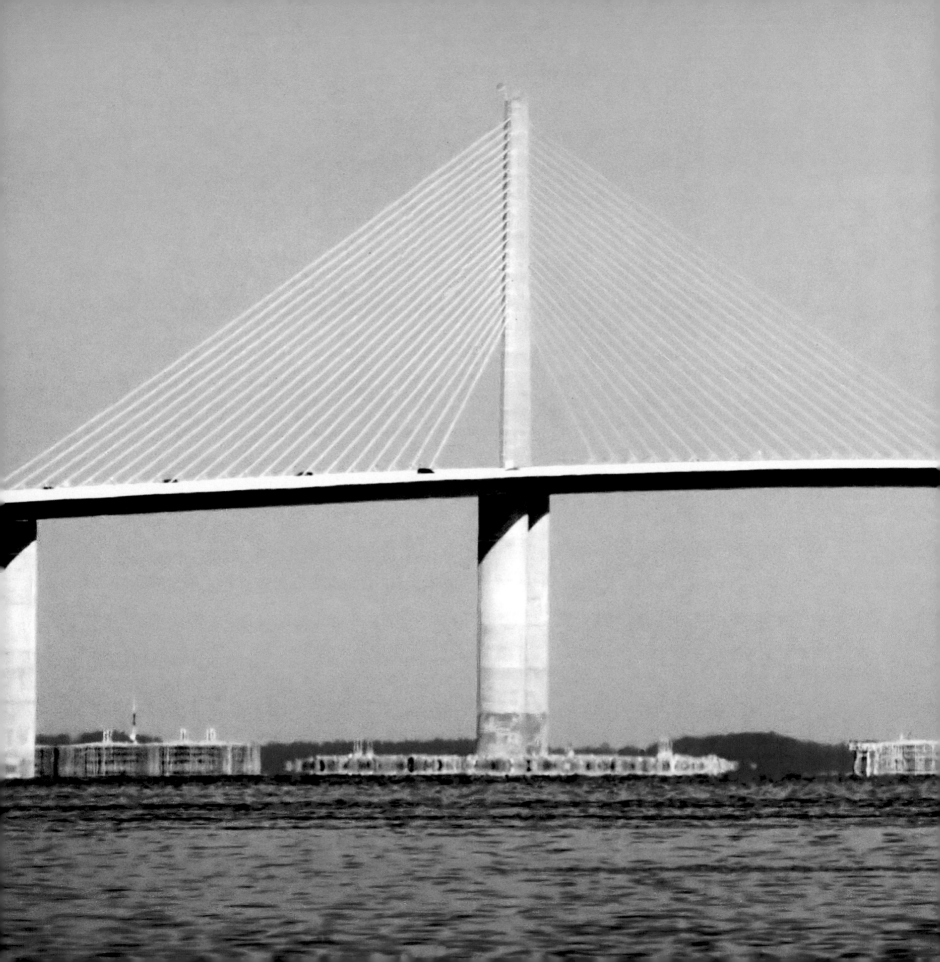

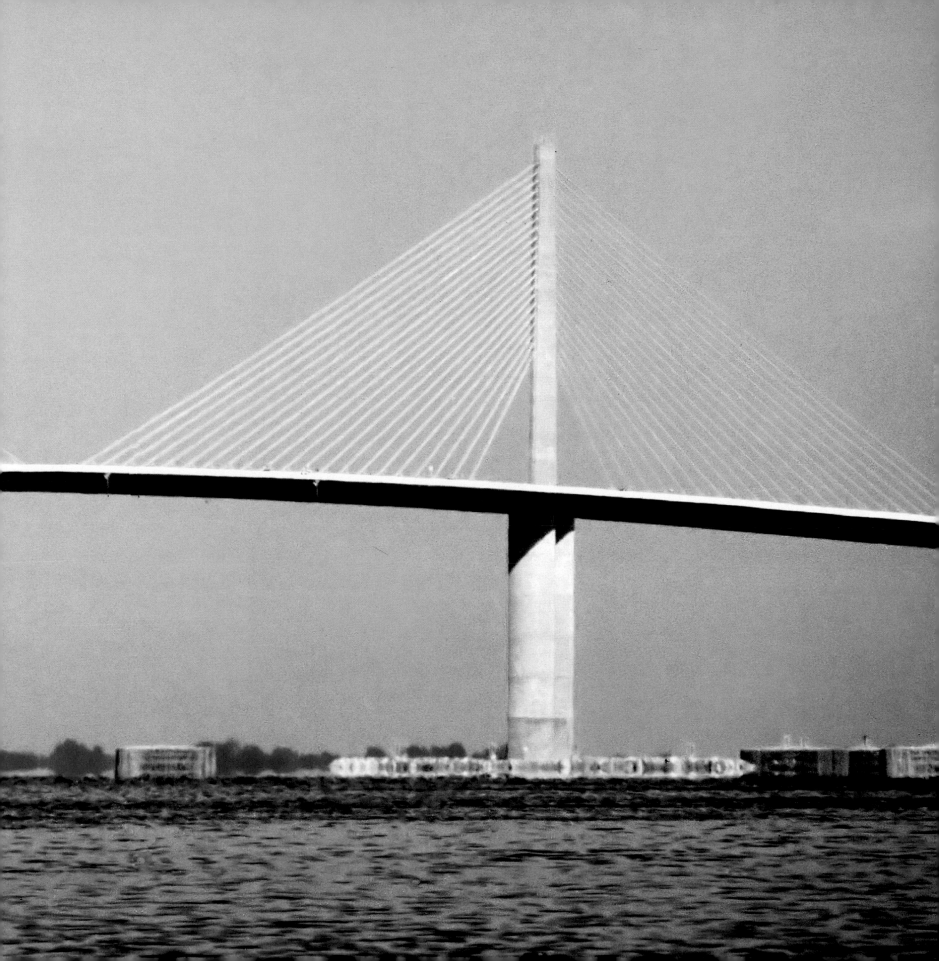

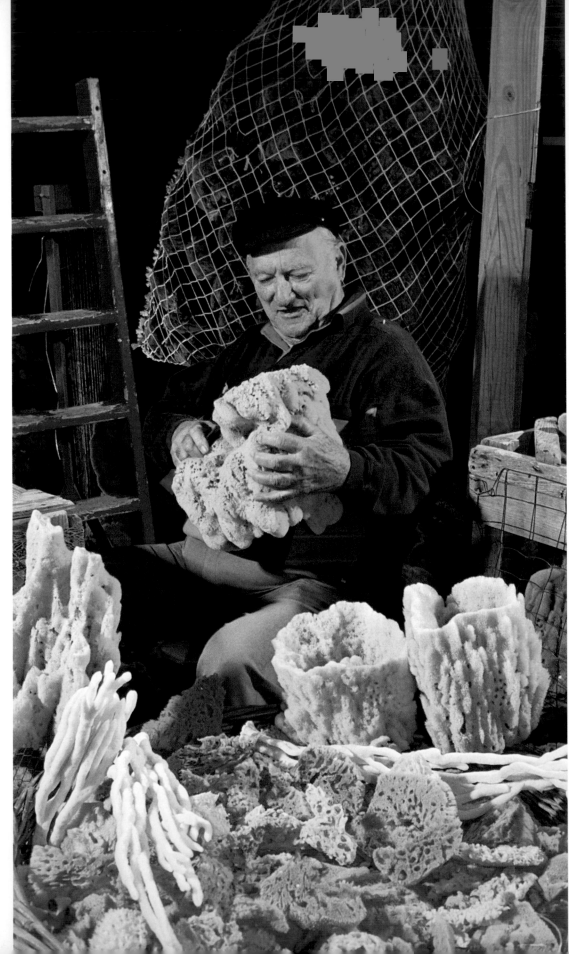

Tarpon Springs is known as the sponge capital of the world. Greek immigrants developed the sponge-harvesting industry in the 1880s and it soon became a prosperous trade. In 1947, a red tide algae bloom wiped out most of the sponge fields, forcing many locals to turn to shrimping.

OPPOSITE PAGE: Spanish moss is a flowering plant that grows most commonly on the Southern live oak and other large trees in the southeastern United States. Spanish moss is often a favorite sight of visiting northerners. These trees are in Madeira Beach, a popular Gulf Coast community.

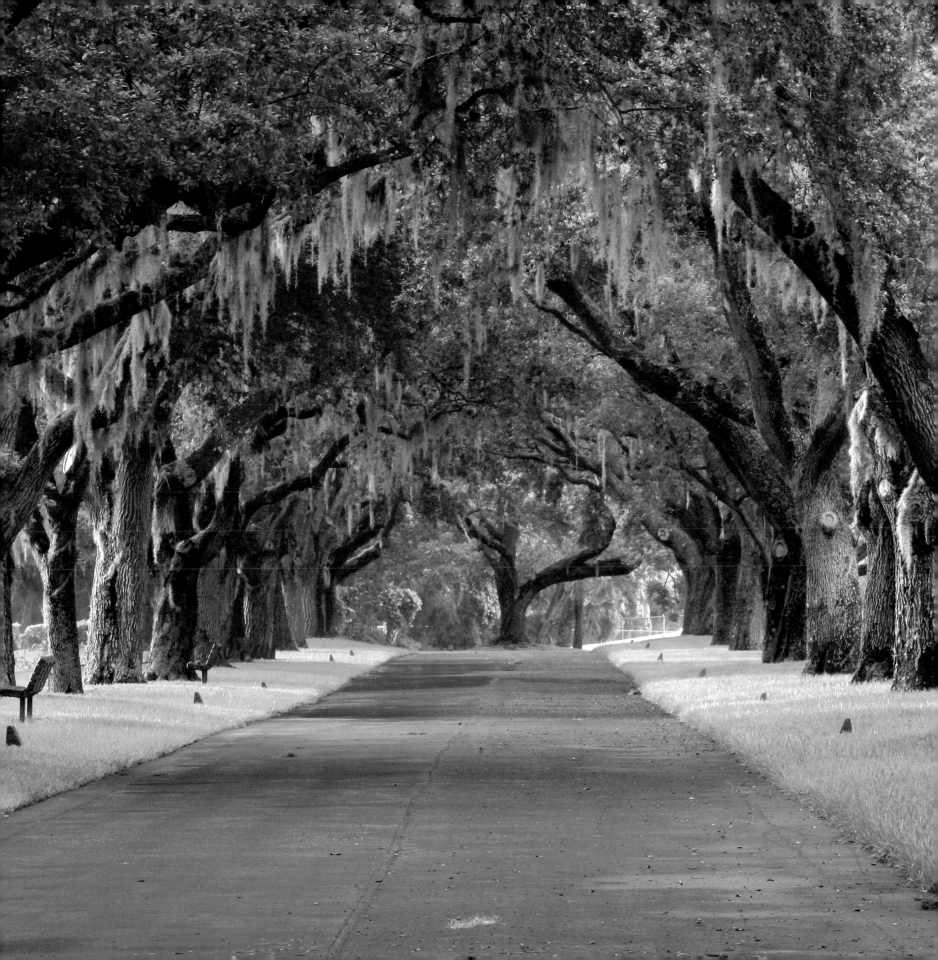

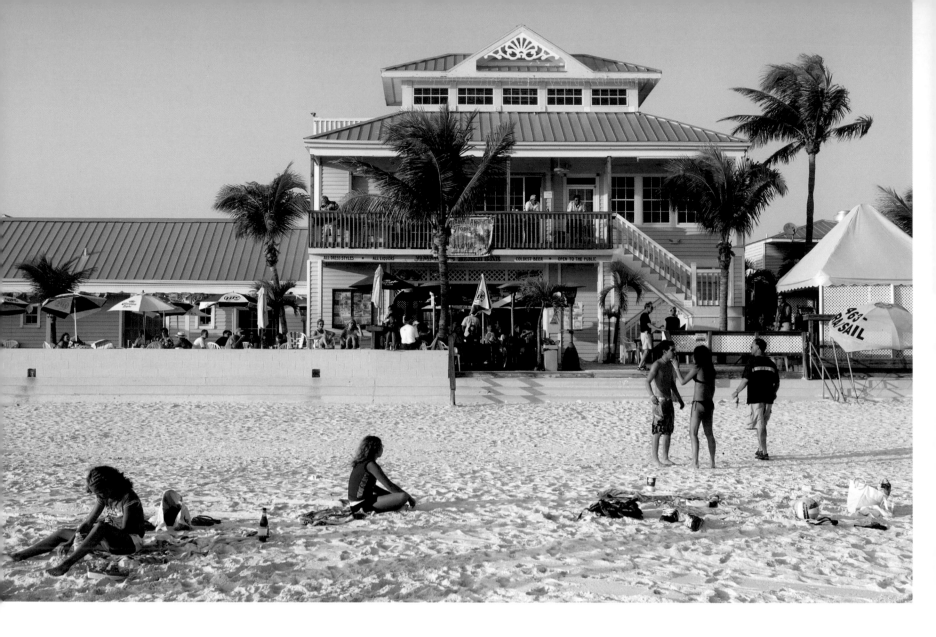

The City of St. Pete Beach is a barrier island community with a permanent population of just over 10,000. Its white, sandy beaches draw numerous tourists and snowbirds.

OPPOSITE PAGE: The pastel pink Don CeSar Hotel in St. Pete Beach was a favorite destination of the pampered rich of the Great Gatsby era, and the sprawling complex still attracts the rich and famous. The Don CeSar opened in 1928 but, after falling into disrepair, was sold to the army and converted into a hospital during the Second World War. The hotel reopened in 1973 and has undergone numerous renovations to bring it back to its original splendor.

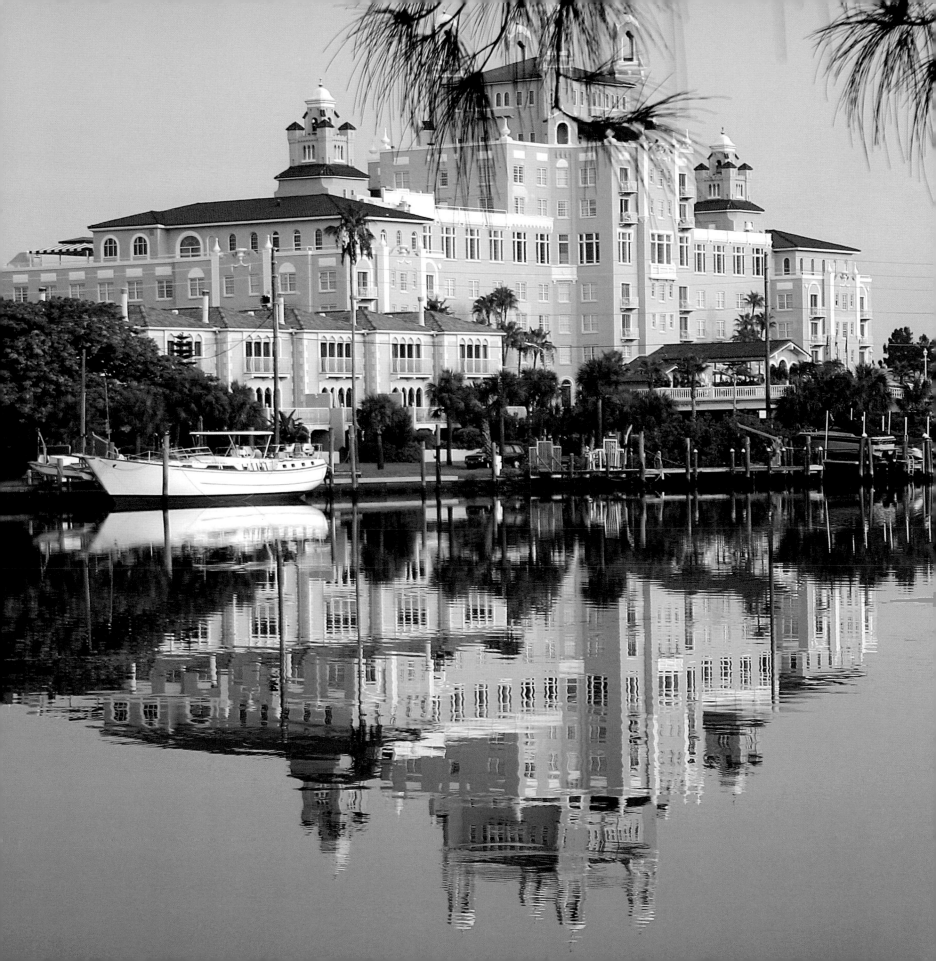

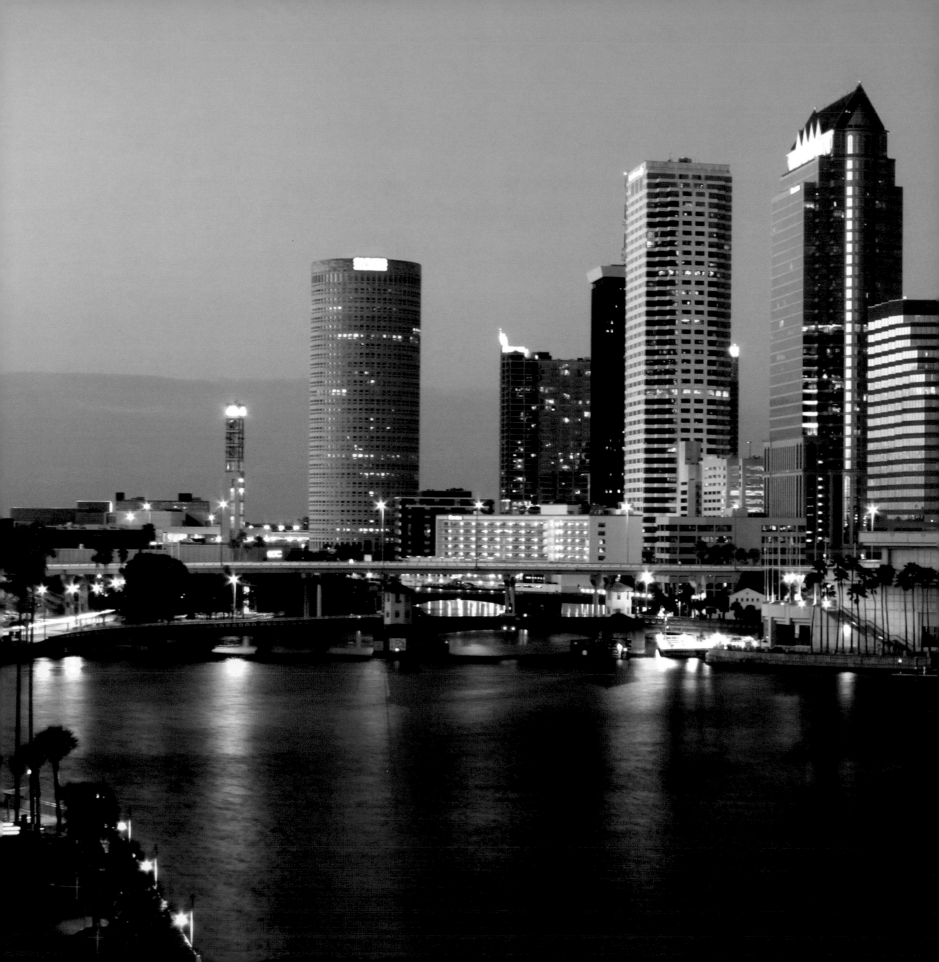

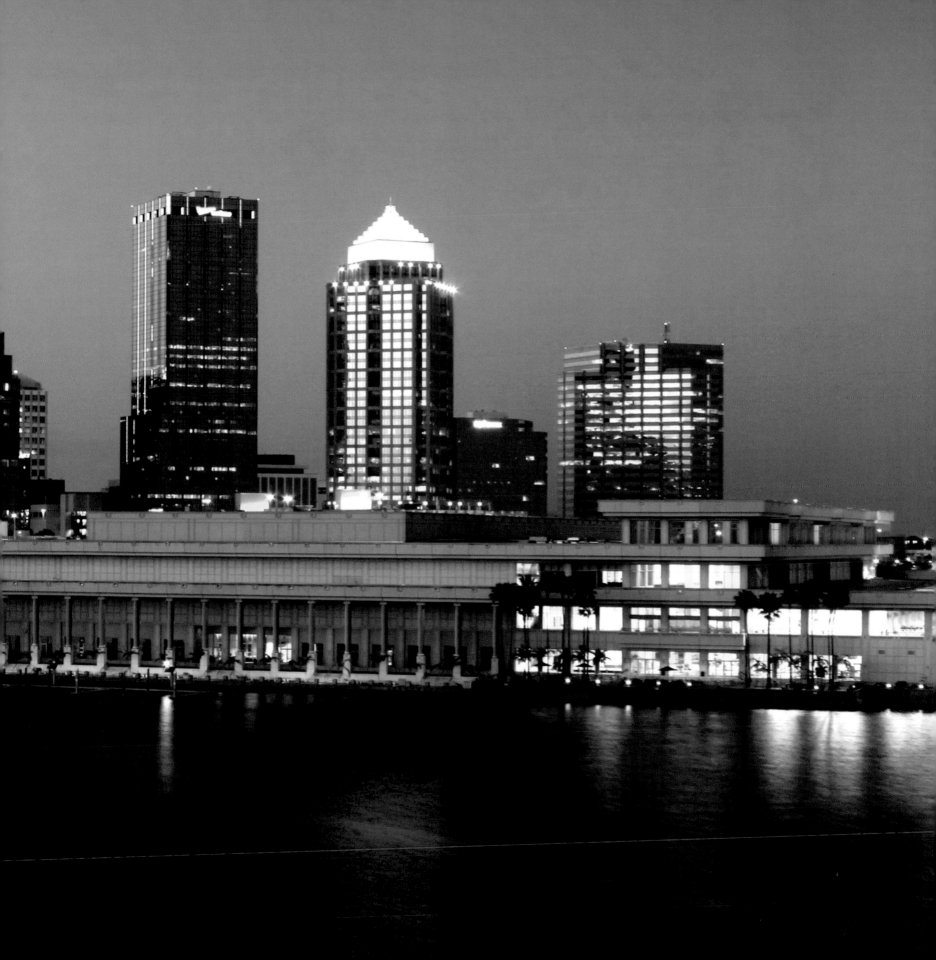

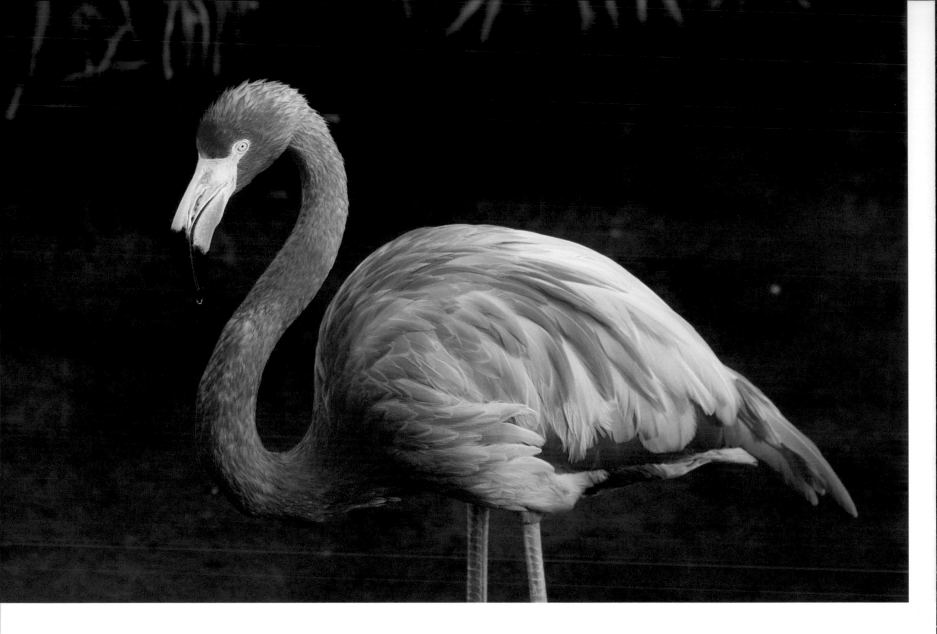

The appearance of flamingos is one of the most colorful signs that you've reached Florida. These large pink birds (47–55 inches in length) are a much-loved part of the landscape.

PREVIOUS PAGE: Tampa is the commercial center of Florida's west coast and a growing seaport. The skyline seen today is largely the result of a building boom during the 1980s and 1990s. The Tampa Convention Center rises from the water in the foreground.

Busch Gardens opened its doors in 1959 as a hospitality facility for the Anheuser-Busch brewery. After the plant closed, the site was further developed and is now a popular tourist attraction.

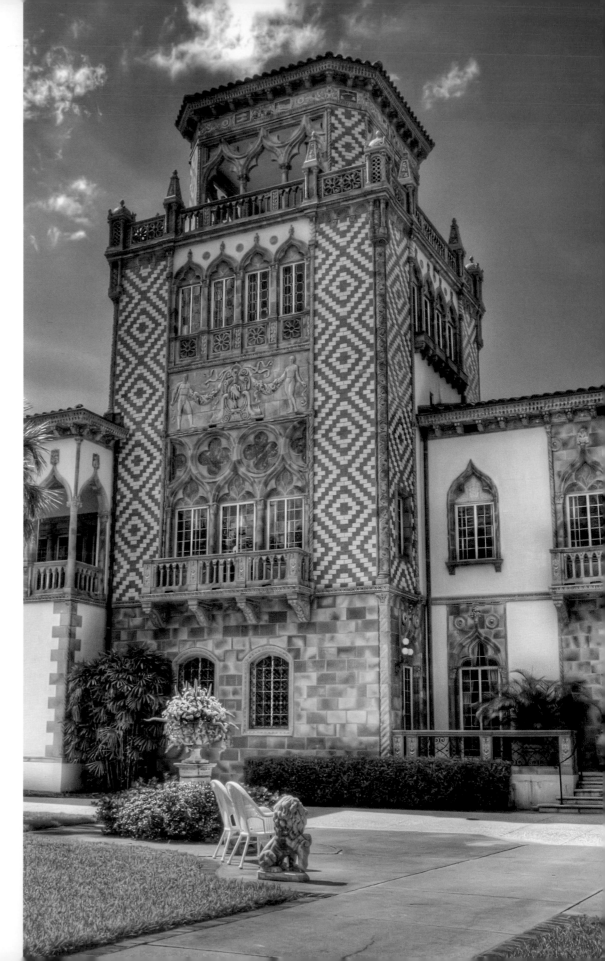

The John and Mable Ringling Museum of Art is housed in this Venetian-style palace built for John Ringling, one of the five original Ringling (Circus) brothers, between 1924 and 1926. The couple acquired a significant art collection, and the estate was bequeathed to the people of Florida. Years of neglect almost destroyed this jewel, but thanks to Florida State University, both the art and the mansion have been restored to their former glory.

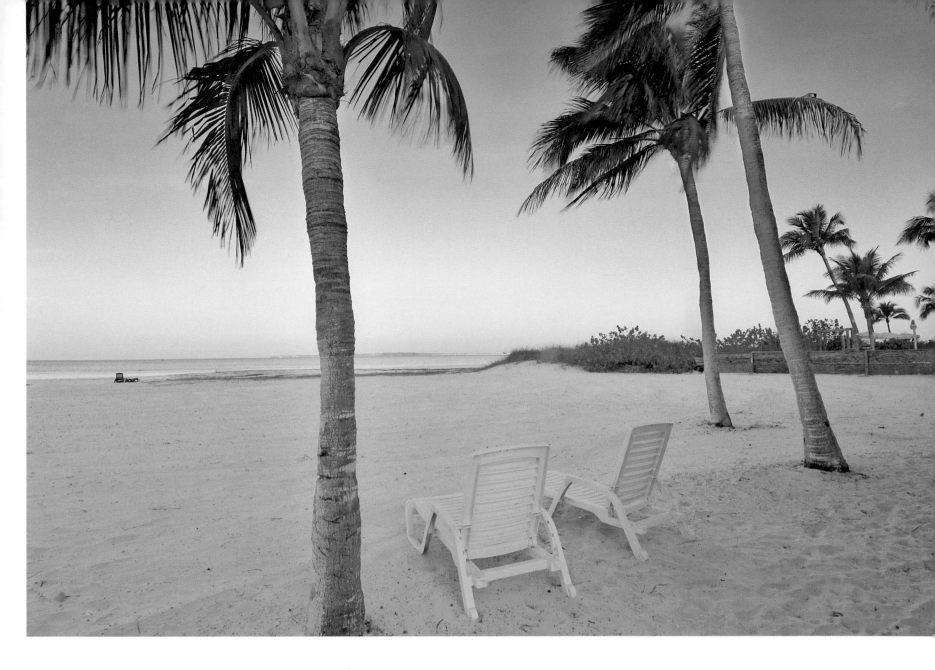

There is plenty of hustle and bustle in Fort Myers, the commercial center of Lee County, but you'd never know it watching the sunset on one of its white sandy beaches.

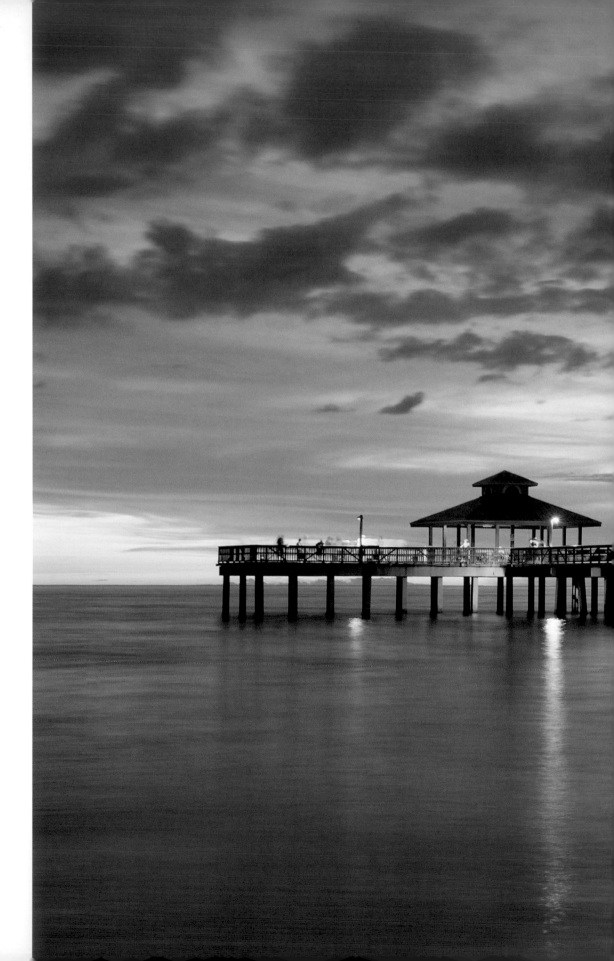

Fort Myers is known for its sandy beaches and beautiful sunsets. Popular attractions also include the mansions built by two of America's most famous inventors: Henry Ford and Thomas Edison.

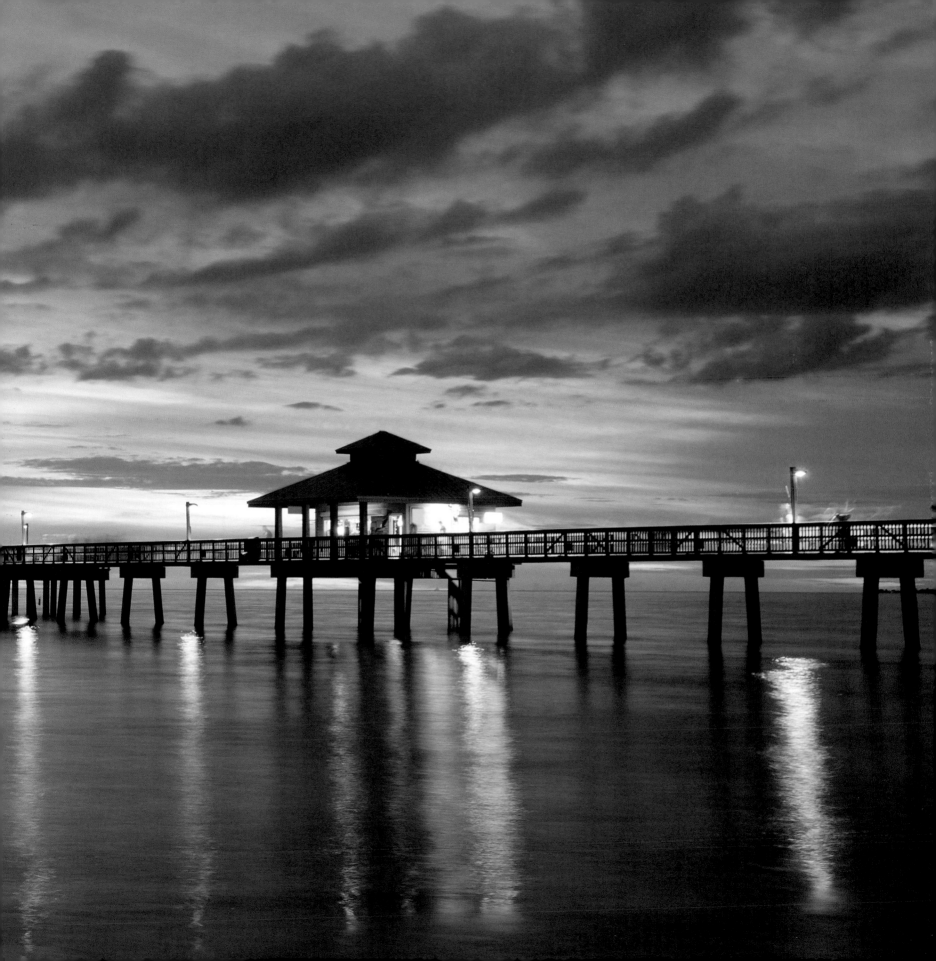

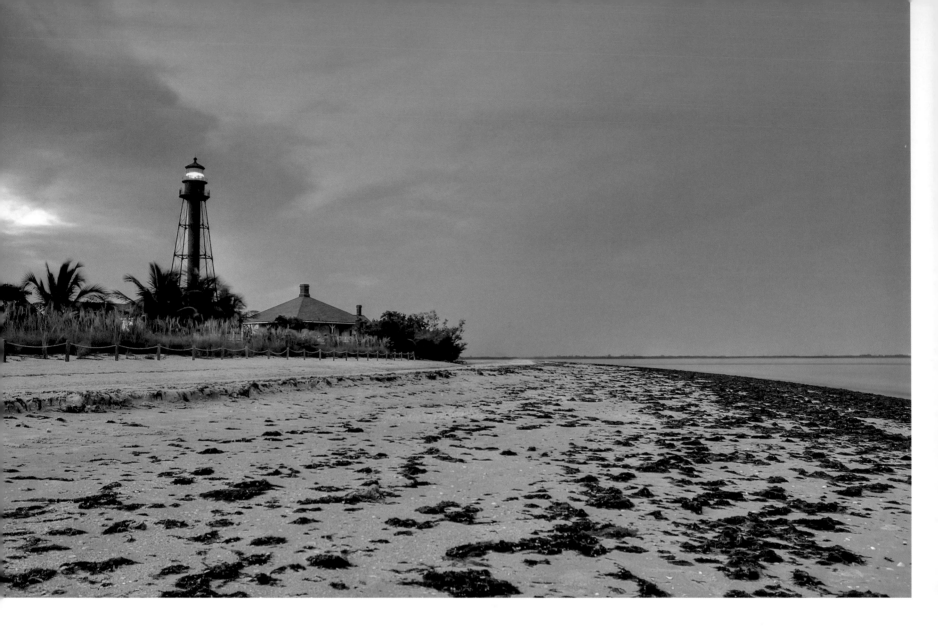

Located just off Fort Myers, Sanibel Island is known as the seashell capital of the world. A wonderful day can be spent gathering shells along 15 miles of unspoiled beaches and there are also 22 miles of bike paths and lots of wildlife to see on the island. Construction on the lighthouse here was completed in 1884.

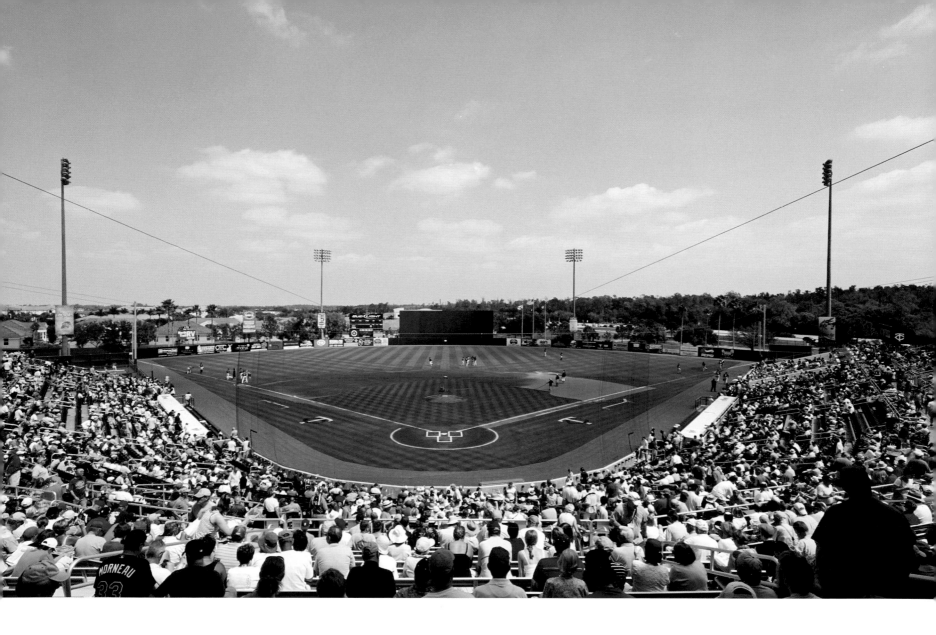

Hammond Stadium in Fort Myers has been the spring-training home of the Minnesota Twins since 1991. Spring training is a Florida tradition that goes back to the early years of the 20th century. The season, which lasts almost two months, draws crowds who enjoy watching their favorite teams play in the Grapefruit League.

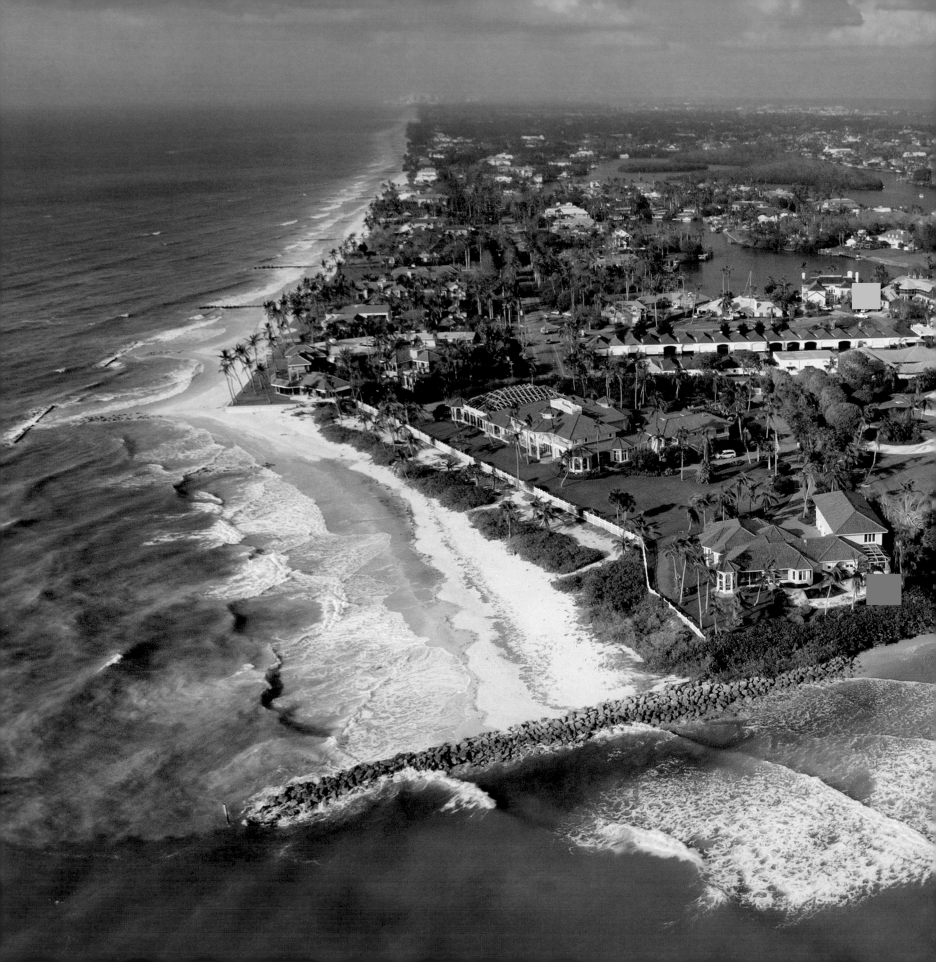

Luxury waterfront homes flank Gordon Pass Inlet in Naples. This "Paradise Coast" city is at once swanky, sophisticated and laidback. It is a popular vacation spot for golfers and a short drive from several major land reserves, including the Corkscrew Swamp Sanctuary.

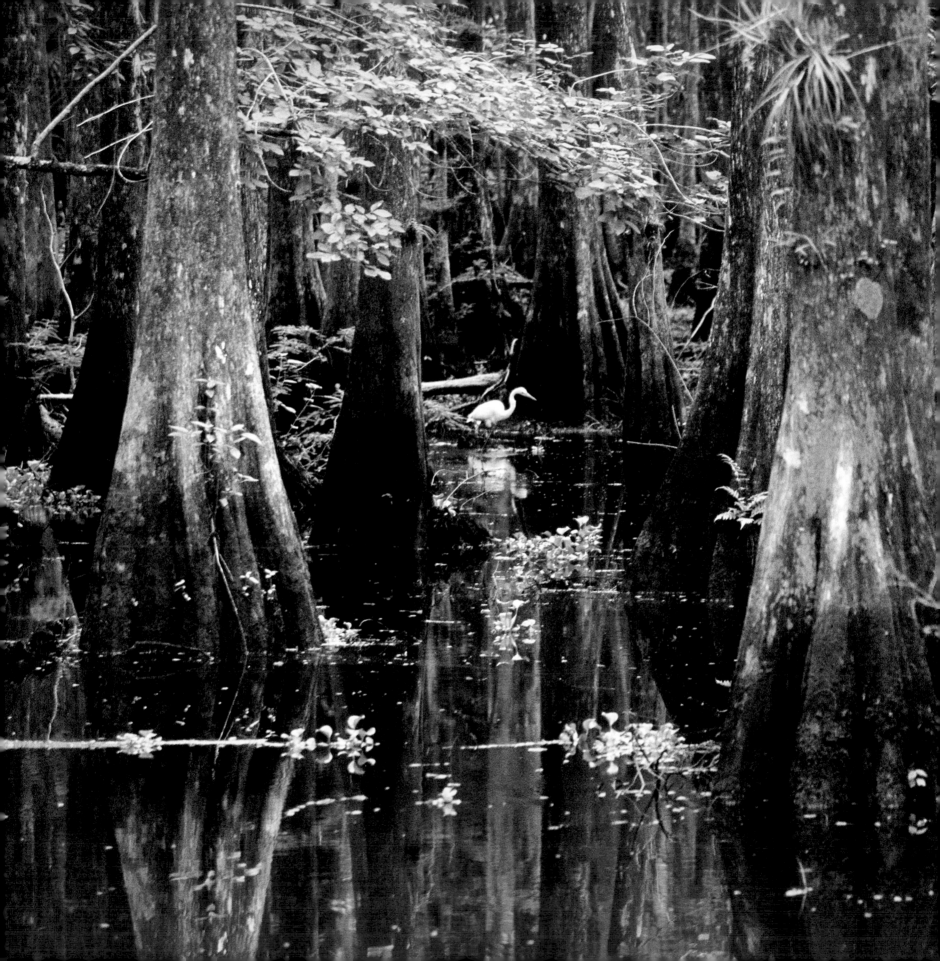

LEFT: No one described the images of the Everglades better than President Harry S. Truman: "Here are no lofty peaks seeking the sky, no mighty glaciers or rushing streams wearing away the uplifted land. Here is land, tranquil in its quiet beauty, serving not as a source of water, but as the last receiver of it. To its natural abundance we owe the spectacular plant and animal life that distinguishes this place from all others in our country."

BELOW: The male American alligator averages between 11 and 14 feet long. These fearsome but wonderful creatures, native to the southern United States, are not hard to find. Florida is thought to have a population of one-and-a-half-million alligators.

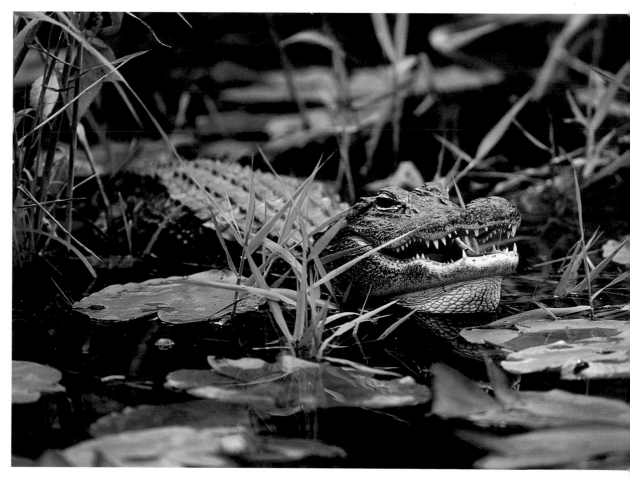

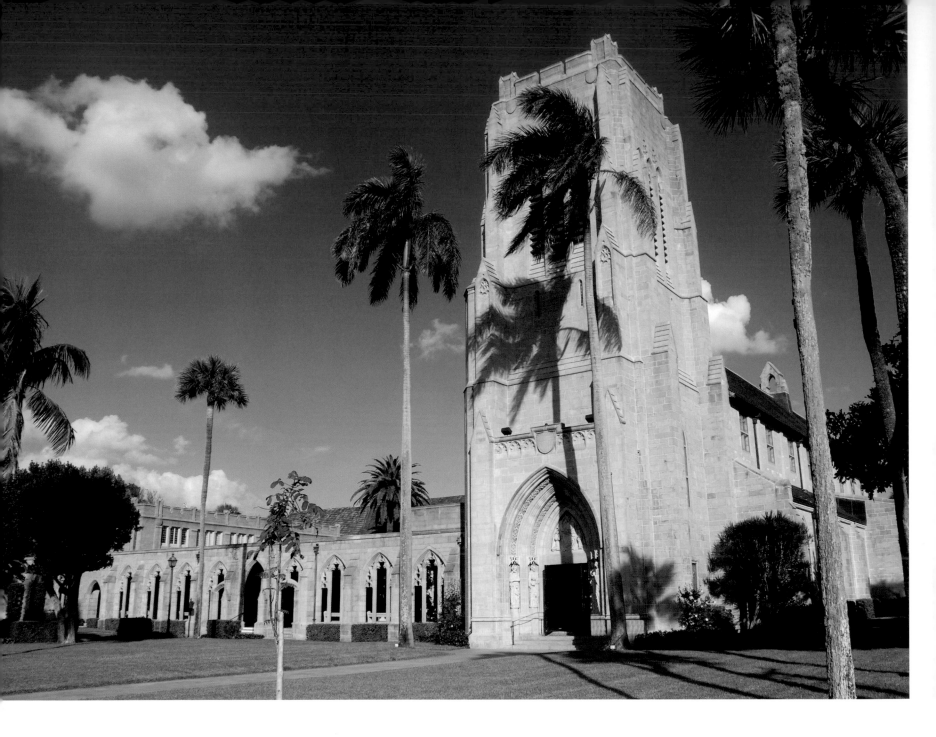

The modified 15th-century Gothic design of Palm Beach's Episcopal Church of Bethesda-by-the-Sea was the first Protestant congregation in southeast Florida when established in 1889. The current structure, finished in 1925, has been the site of several famous weddings, including that of Donald Trump and wife Melania.

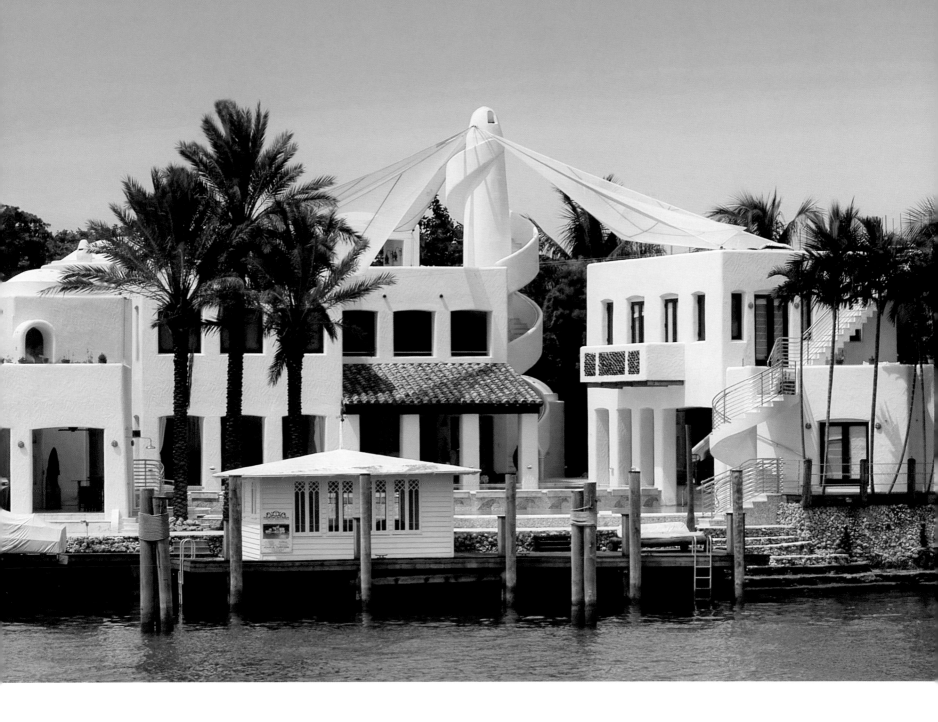

Just like in many other coastal Florida cities, the elite of Palm Beach choose to live right on the waterfront where they can dock at their doorsteps. The architectural styles of these sprawling mansions vary from classical and reserved to modern and whimsical.

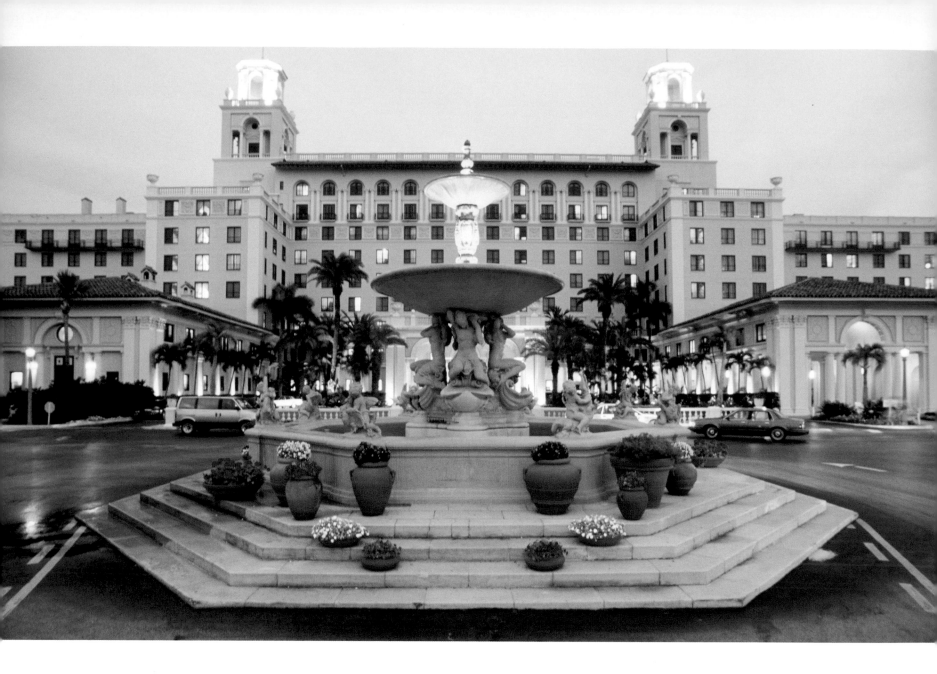

In 1896, Standard Oil magnate Henry Flagler built the Palm Beach Inn. He soon doubled the structure's size and renamed it The Breakers after guests continued to request rooms "over by the breakers." In 1903, during one of several expansion projects, the hotel burned to the ground; a year later, it reopened to critical acclaim and guests such as the Rockefellers, Vanderbilts, American presidents and European royalty have all stayed here and it continues to attract the rich and famous.

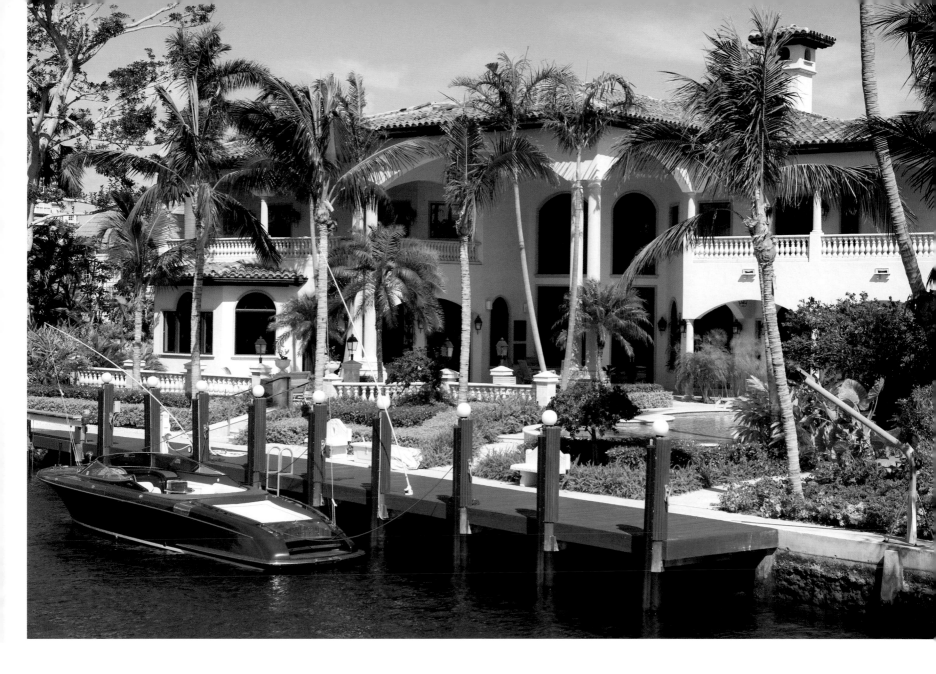

Boating may be a favorite pastime in Florida, but it's a lifestyle in Fort Lauderdale. Many families have some sort of watercraft – whether it's a luxury motorboat such as this one found on Millionaires Row, or a simple kayak.

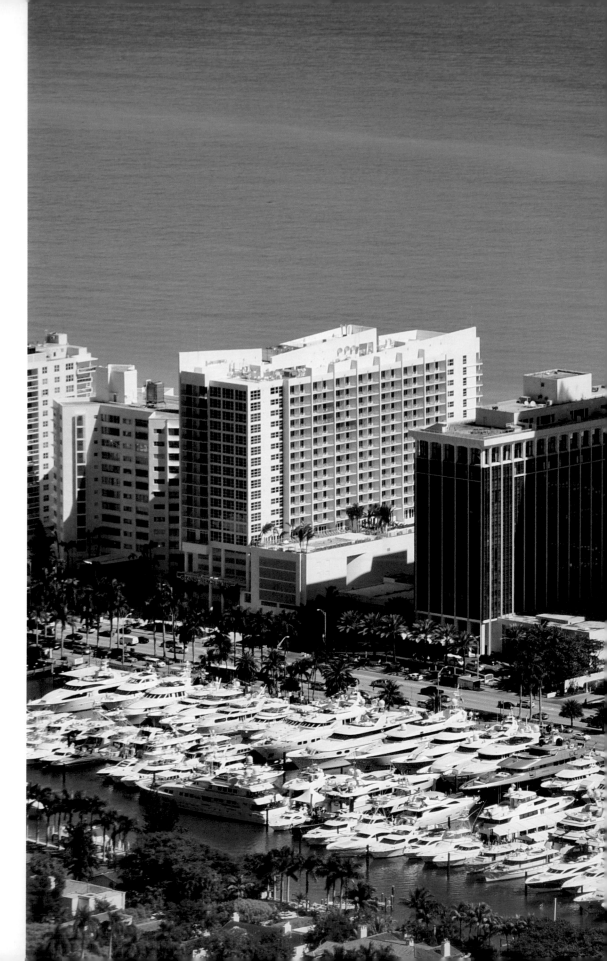

The annual Miami International Boat Show is one of the world's top boating events, showcasing everything from inflatables to luxury yachts. Tens of thousands of boaters from around the world are drawn to the five-day event.

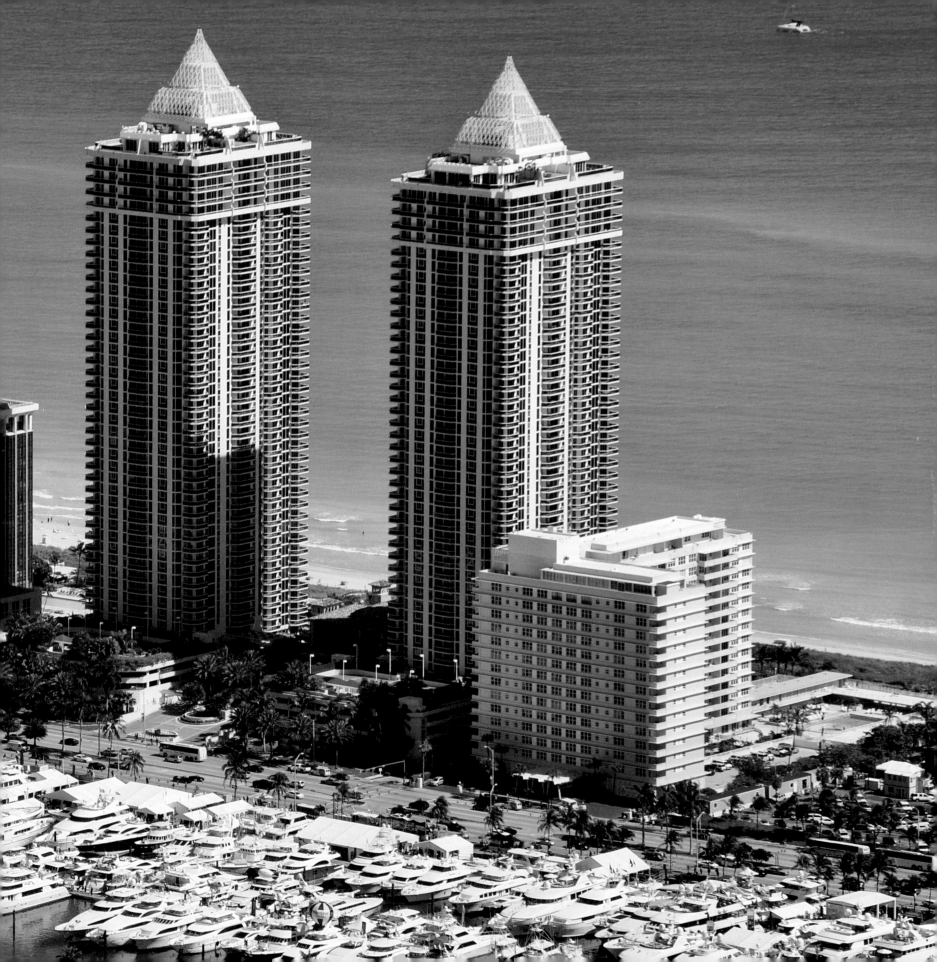

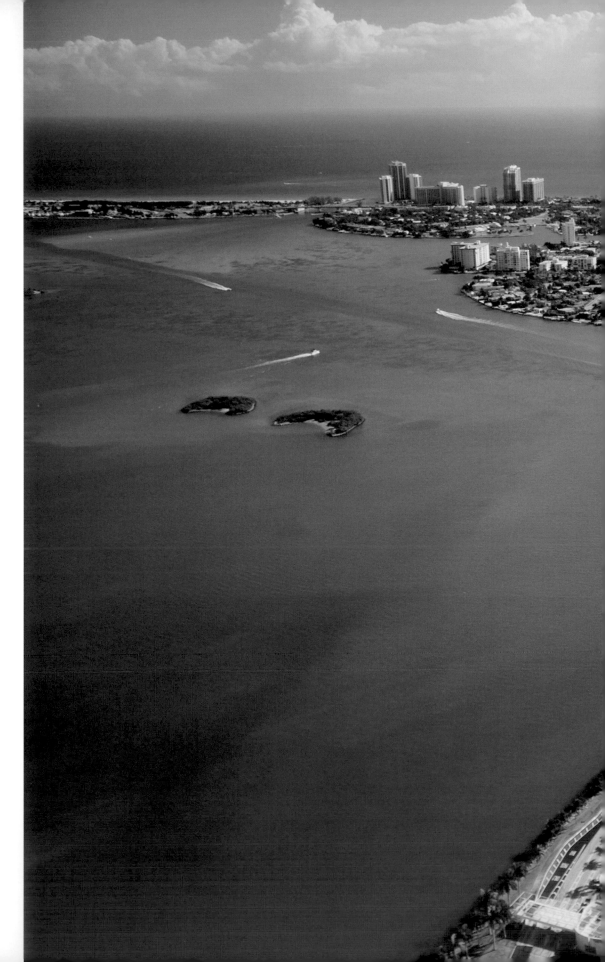

Miami seems to rise from the ocean, and has something to suit every style, whether you prefer to be seen at the hottest club or relax at an old pastel diner on a shady back street. The things that draw everyone here are the sun and the waves.

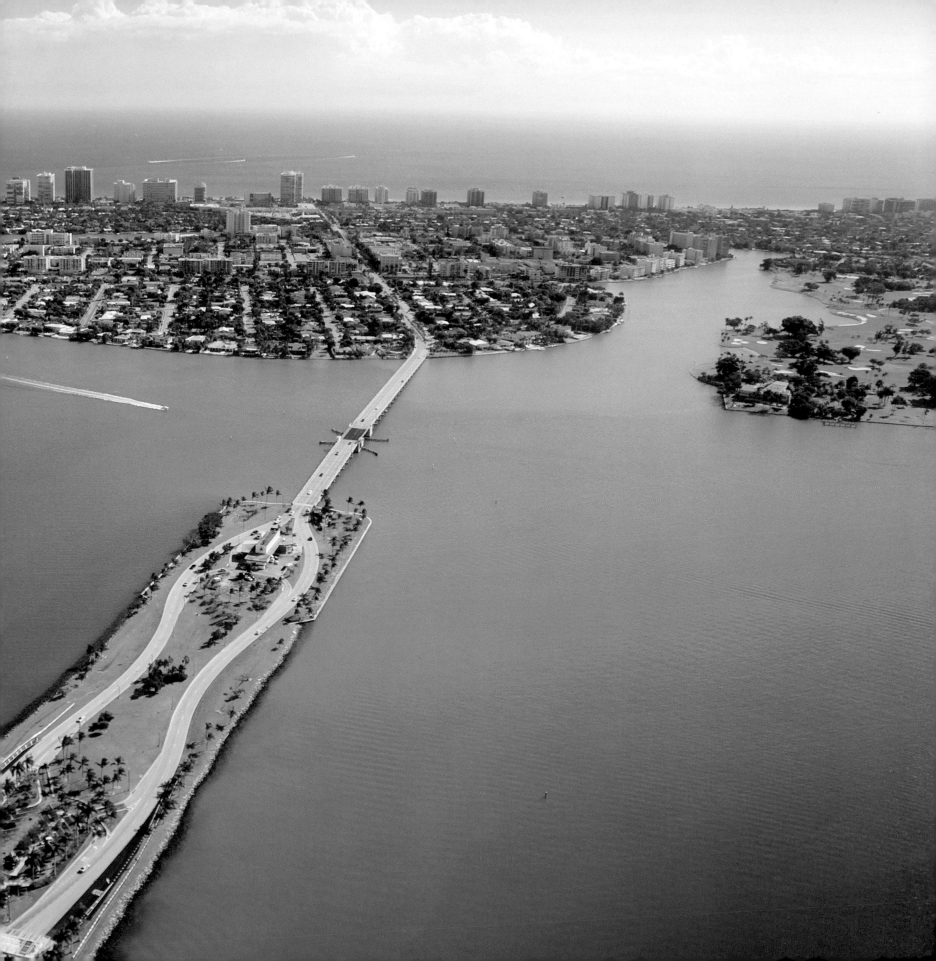

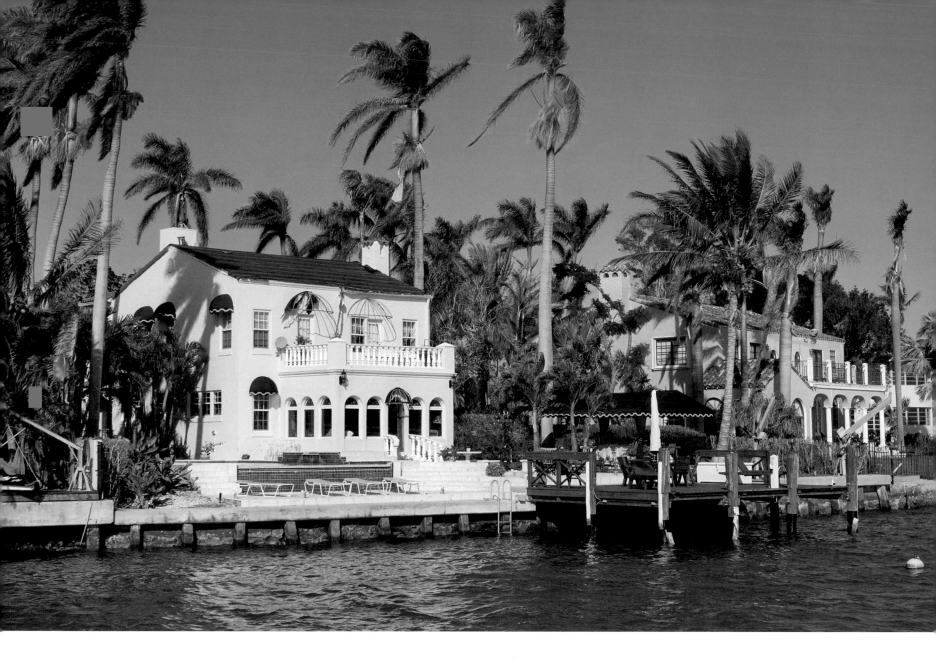

Miami has some of the nation's most dazzling concentrations of mansions, many flanking the water's edge and surrounded by palm trees.

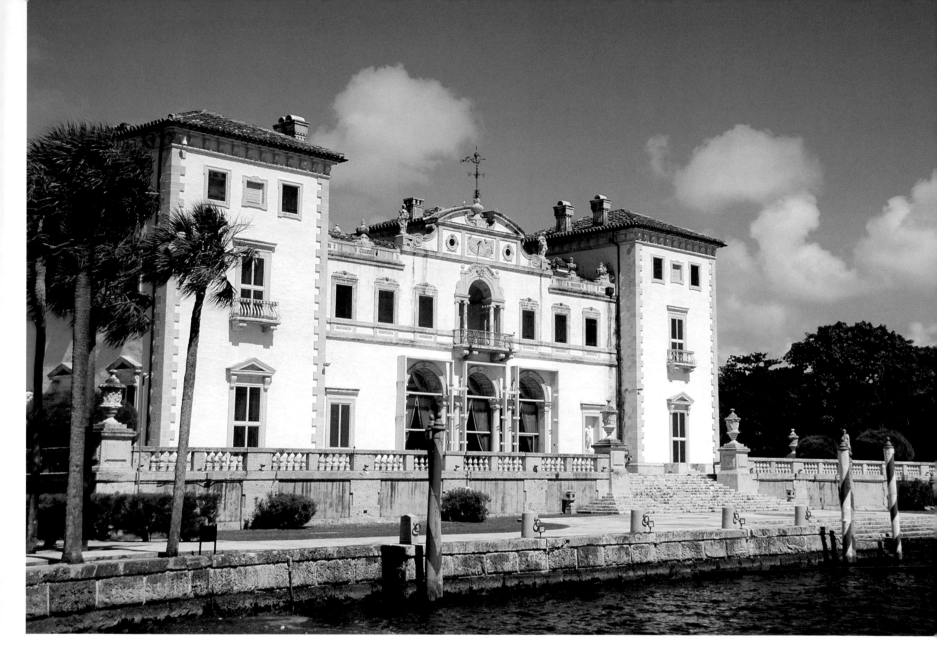

Vizcaya was the winter residence of the industrialist James Deering from 1916 until his death in 1925. During construction of the Italian Renaissance–style mansion, more than a thousand workers were employed, nearly one-tenth of Miami's total population. After Deering's death, Vizcaya suffered from several hurricanes and the extensive estate began to be sold off. In the 1950s, the heirs generously gave the house and gardens to Dade County and both are open to the public.

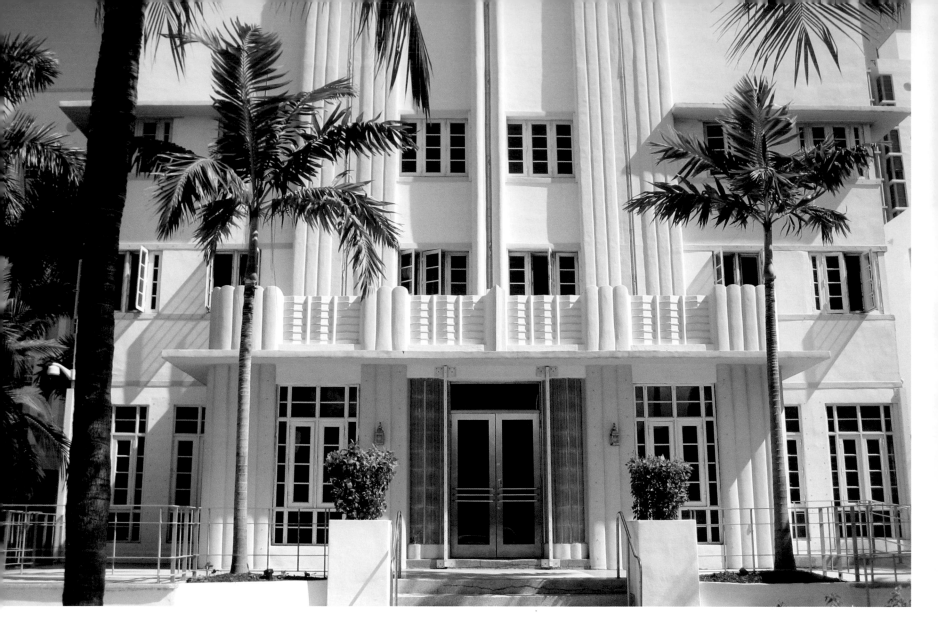

Art Deco structures, considered ultramodern when they were put up in the 1920s and 1930s, still line a good part of South Beach. The finest examples are concentrated on Ocean Drive, Collins Avenue and Washington Avenue.

OPPOSITE PAGE: Art Deco in Florida is characterized by neoclassical structures stylized with exotic motifs and pastel colors. The buildings began to fall into disrepair over the years and debate raged in the 1970s over whether to demolish many of them. Thankfully, most of these Miami Beach treasures were lovingly restored and added to the National Register of Historic Places.

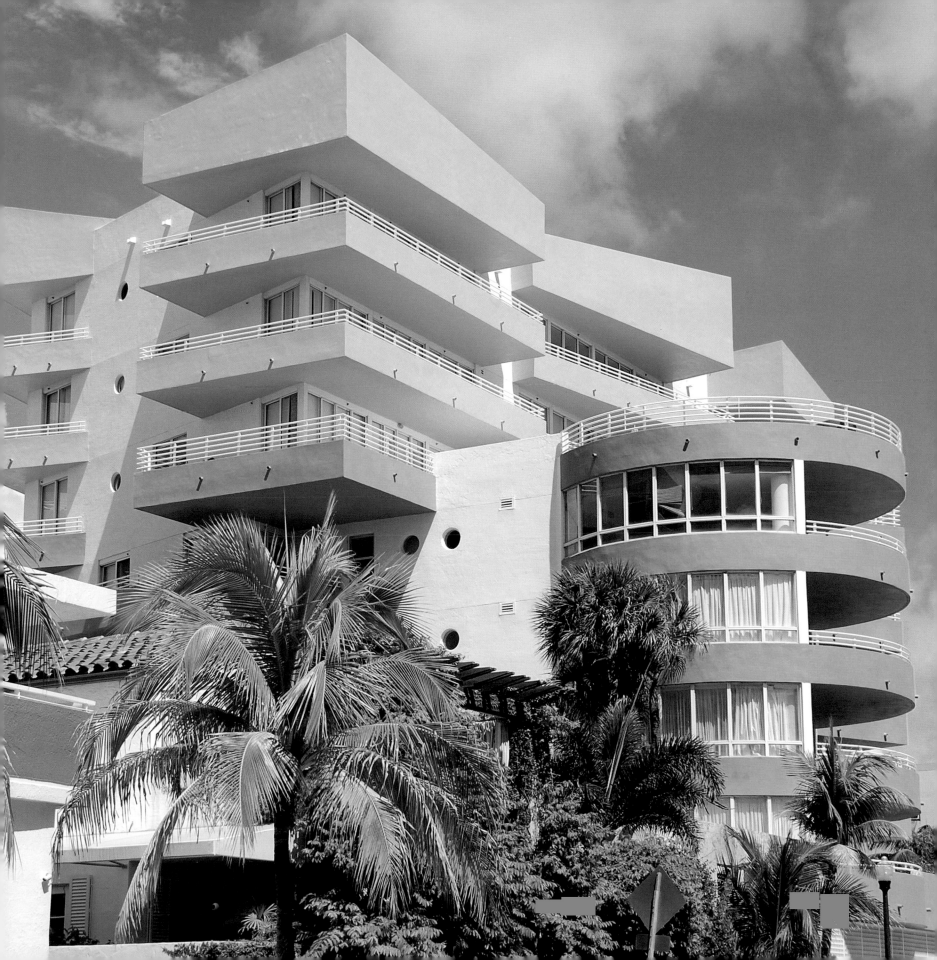

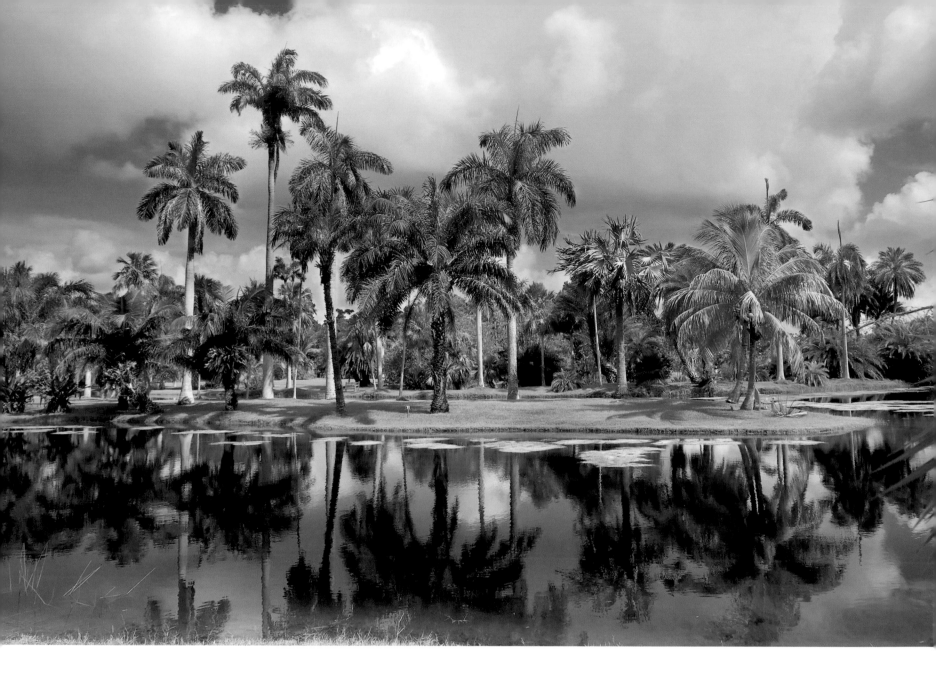

The Fairchild Tropical Botanical Gardens, named after the botanist David Fairchild, is an 83-acre paradise located in Coral Gables. The gardens were established in 1936 by Robert H. Montgomery (1872–1953), and today attract thousands of visitors.

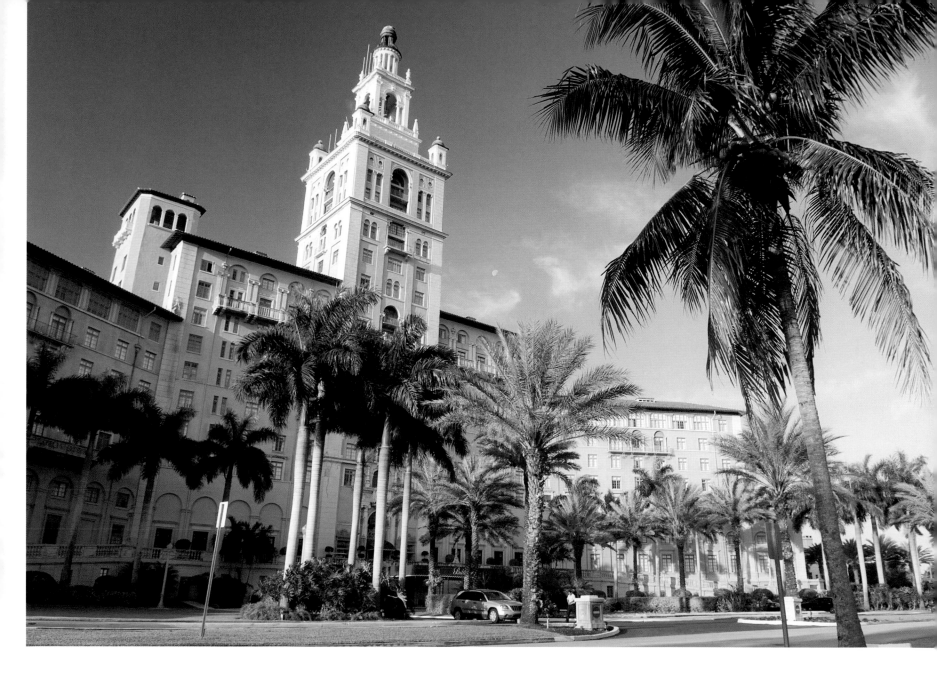

The Biltmore Hotel opened on January 15, 1926, and from the very start was meant to be one of the grandest resorts in the country – complete with a 400-room hotel, country club with 18-hole golf course, polo fields, tennis courts, and an enormous swimming pool. The Biltmore was the place to be during the Jazz Age, but during the Second World War was converted into a hospital. The city of Coral Gables acquired ownership in 1973, and 14 years later it reopened in all its former glory.

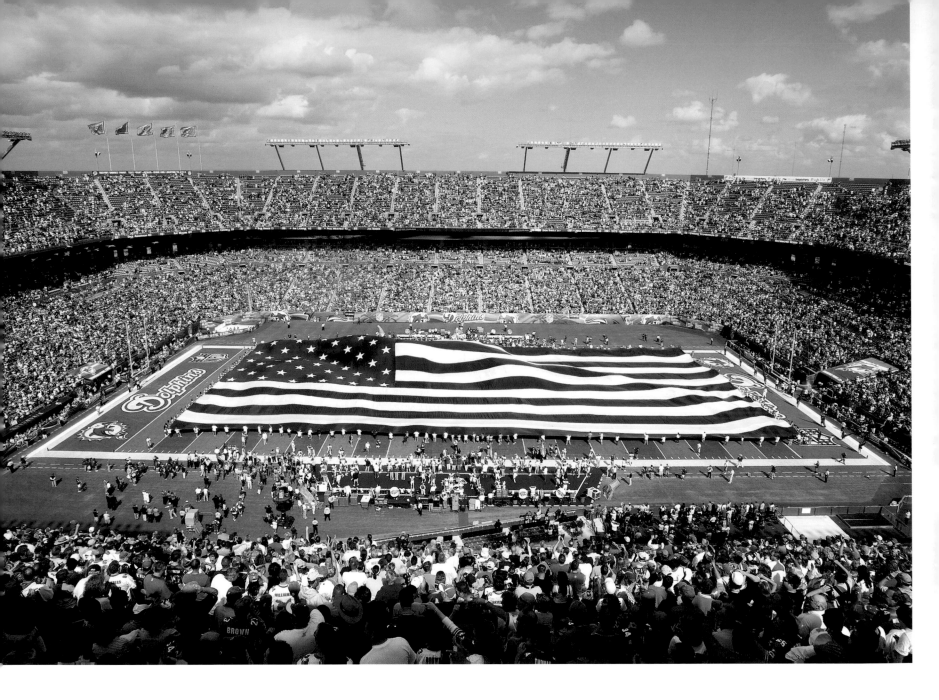

Sun Life Stadium is the home of the Miami Dolphins, the Florida Marlins and the Miami Hurricanes. Since it was completed in 1987, the stadium has hosted five Super Bowls. Originally known as the Joe Robbie Stadium, it revolutionized the economics of professional sports when it introduced club levels and executive suites with first-class facilities.

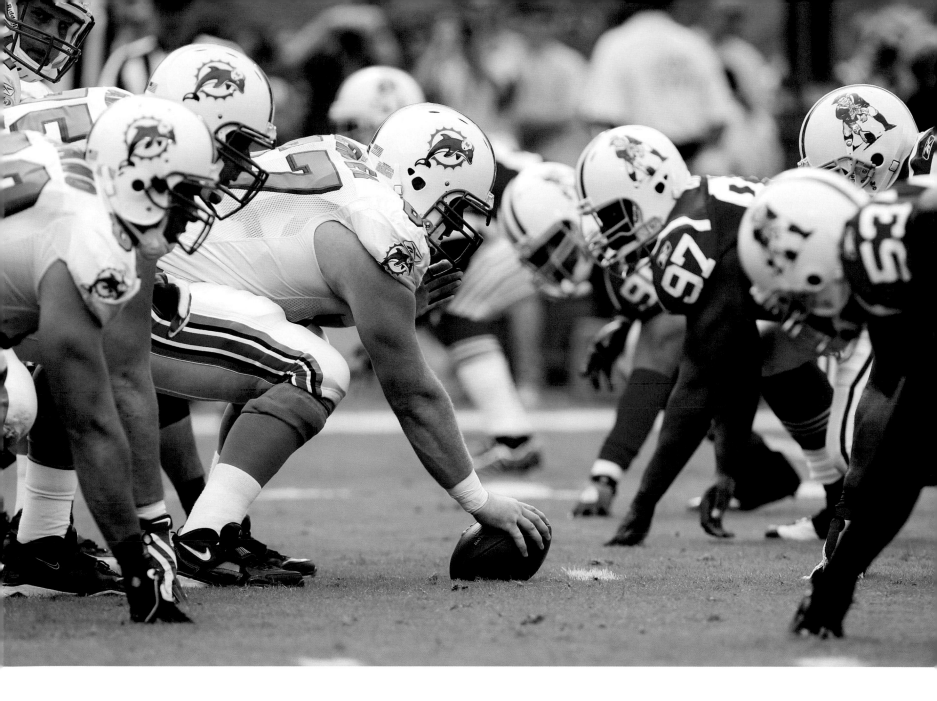

Established in 1966, the Miami Dolphins are one of Florida's best-loved football teams. For most of their history they were coached by the legendary Don Shula, who led the team to two Super Bowl victories.

Miami Beach's Espanola Way has a dramatic past. Once a meeting place for the rich, its personality changed when gangsters, and then the rumba beat, moved into the area. The early 1980s saw a dramatic rebirth for the area. Today the Art Deco street is known for its character and charm.

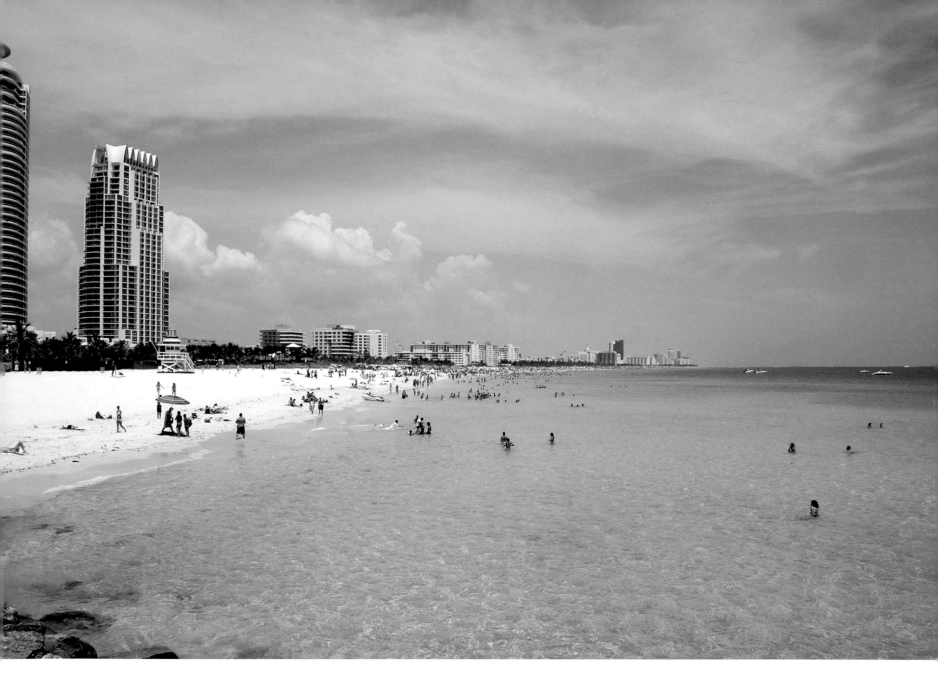

Miami Beach developed into America's Riviera during the 1950s. The resort hotels that sprung up fell into disrepair, but since the late 1980s Miami Beach has experienced a dramatic rejuvenation.

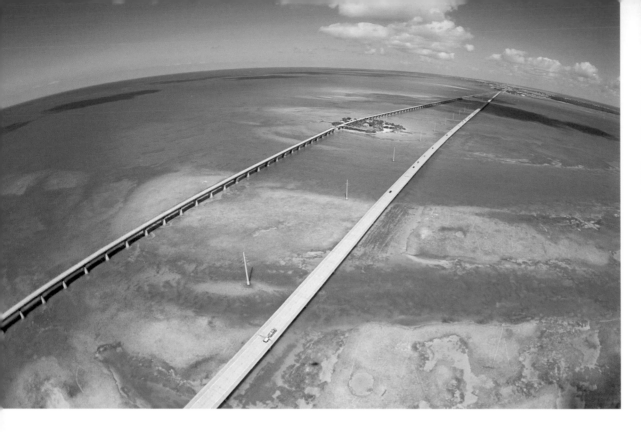

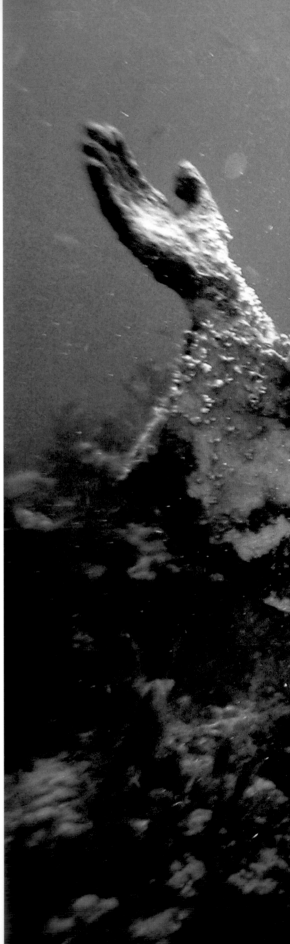

ABOVE: An aerial view during extremely low spring tides shows Seven Mile Bridge in all its glory. The seemingly endless bridge connects two of the Florida Keys and was one of the longest bridges ever built when constructed between 1978 and 1982. Made up of 440 concrete spans, Seven Mile Bridge rises dramatically near its center to allow for a 65-foot clearance for boat traffic.

RIGHT: The nine-foot bronze "Christ of the Deep" is the third of its kind; the first two stand in the waters off Genoa and Grenada. This underwater statue was lowered into place off Key Largo in 1965 and has withstood hurricanes and corrosion.

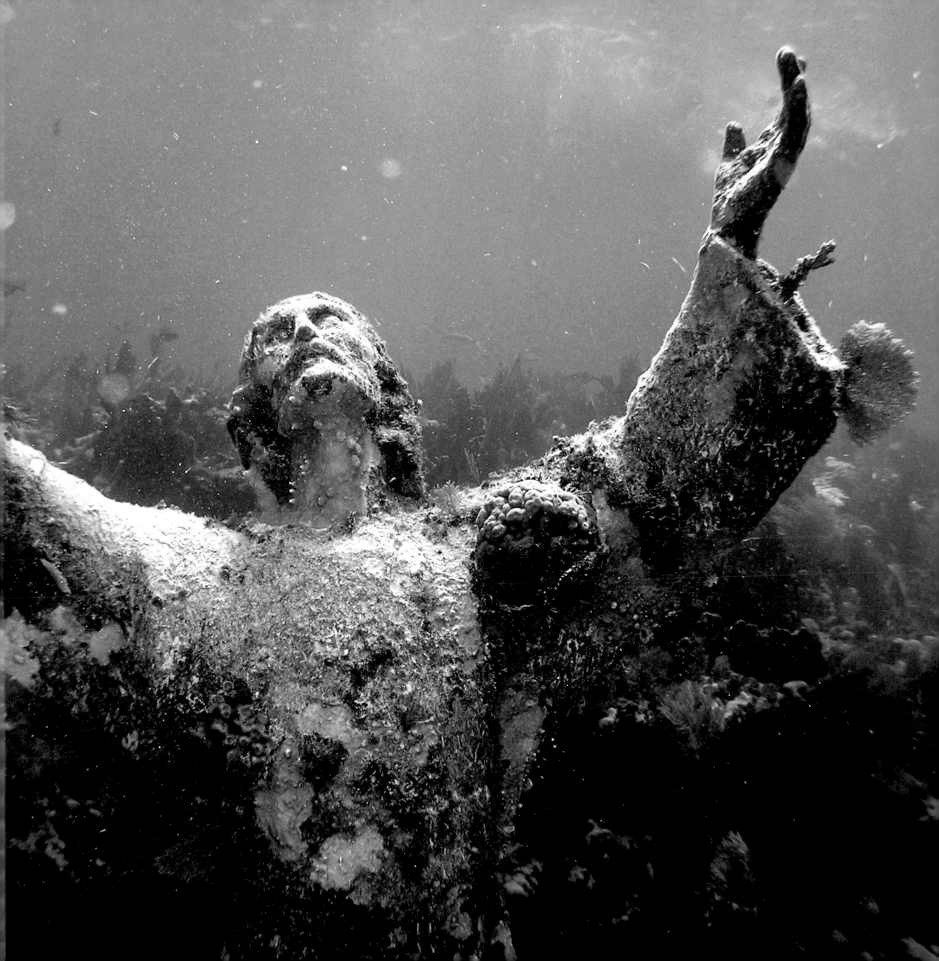

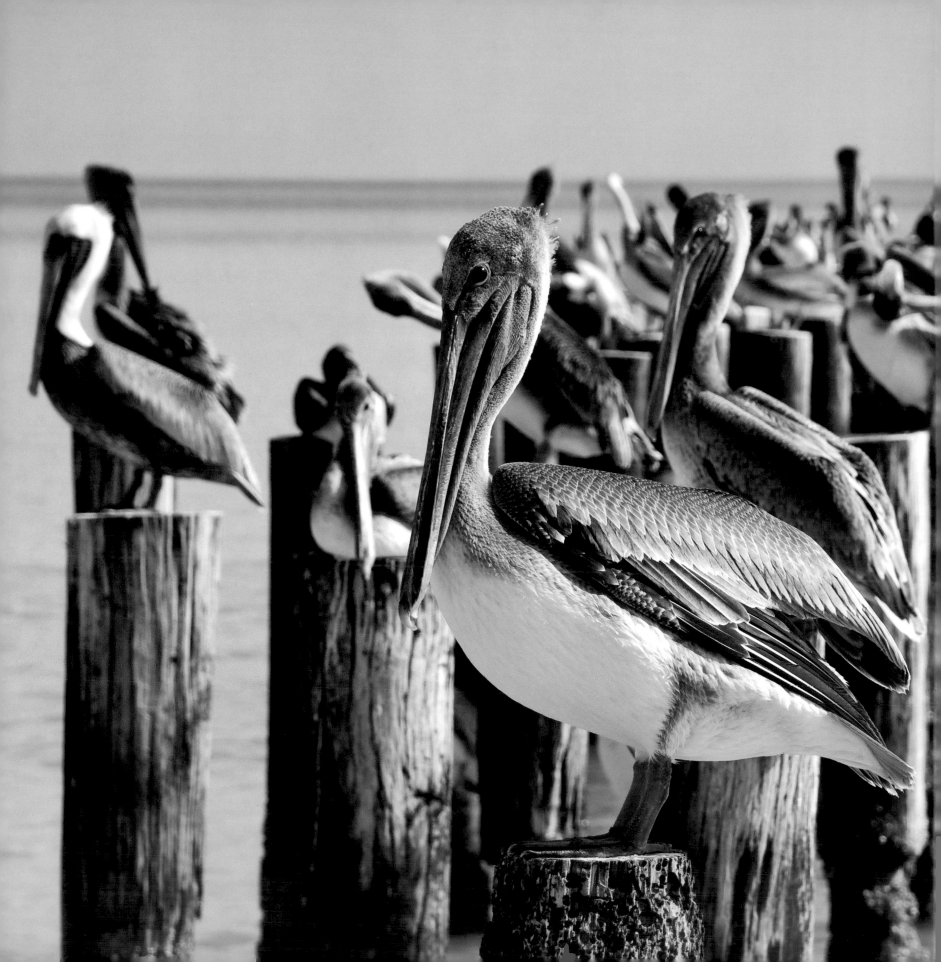

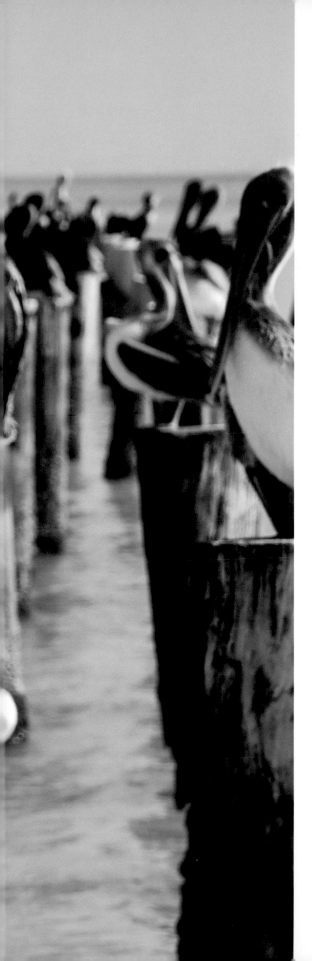

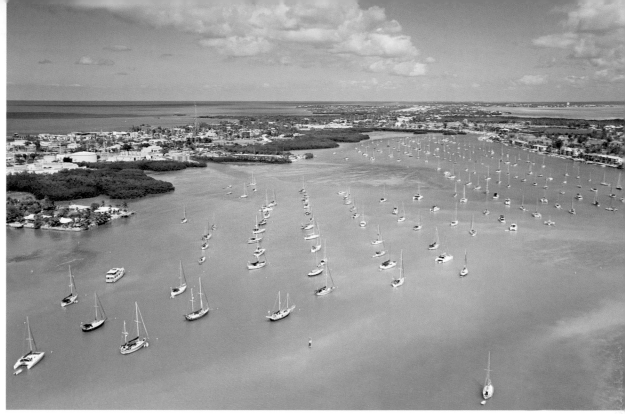

ABOVE: Anchored sailboats form orderly rows off Marathon Key. Back in 1820, only 14 people resided here; nearly two centuries later the population has risen to about 10,000. Marathon is a major sport-fishing destination, attracting visitors from all over the nation.

LEFT: Florida is home to many beautiful species of birds uncommon to other parts of the country. Many rare species of pelicans prefer the temperate environment of Florida and the southern states. One of the distinguishing characteristics of the pelican is the pouch under its beak.

FOLLOWING PAGE: Boca Chica is a small lighthouse 12 miles south of the towering Cape Florida lighthouse on Key Biscayne. The island was originally privately owned but passed into the hands of the U.S. National Park Service, which maintains the distinctive architectural treasure today.

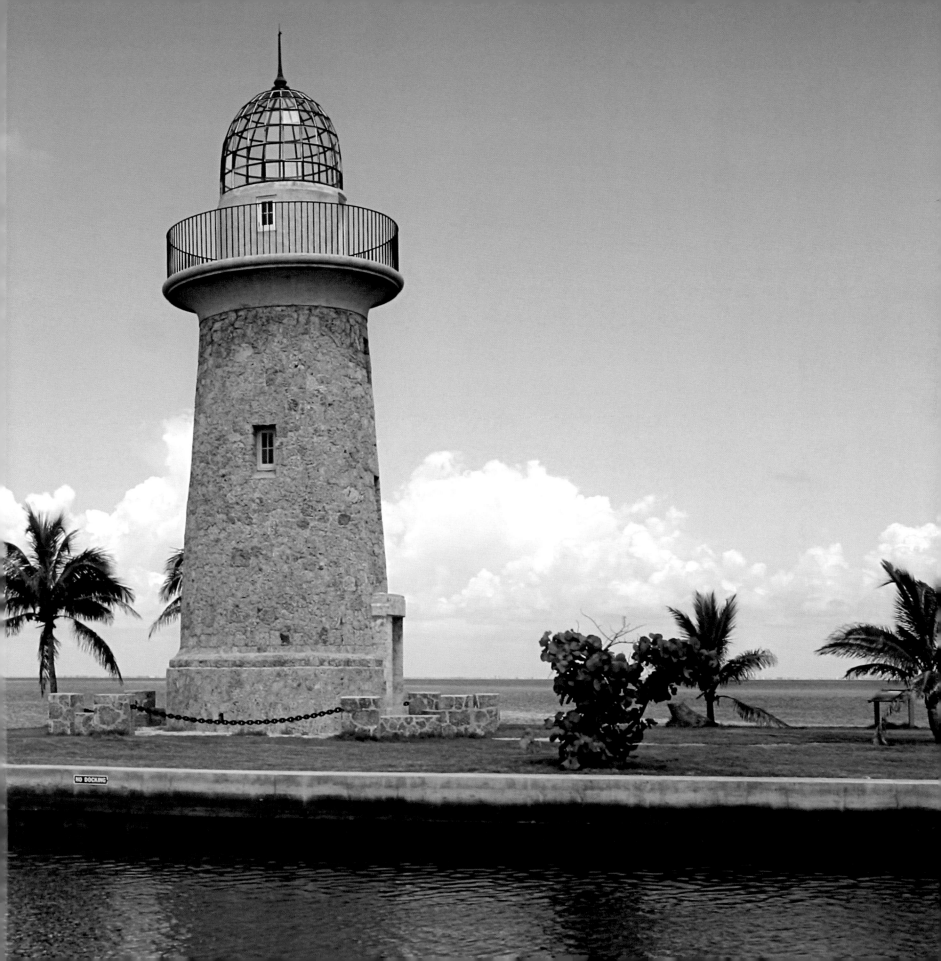

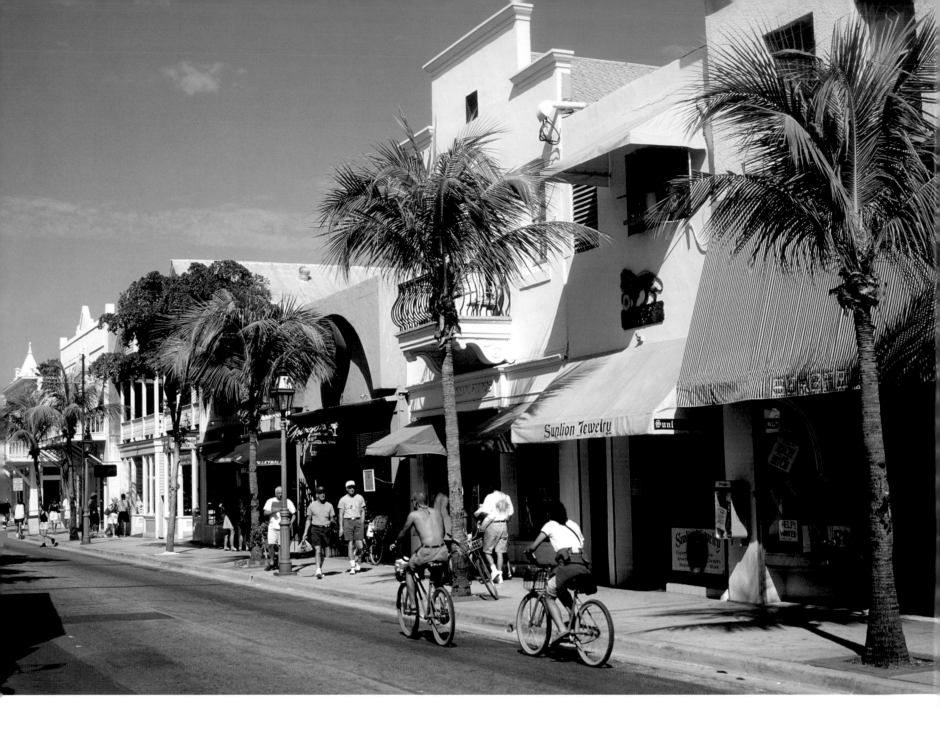

In Key West, Duval Street is the center of action, day or night. The street, which stretches from the Atlantic to the Gulf, was named for William Pope Duval, the first territorial governor of Florida. Although historic buildings line the way, the area has always been known for its party spirit.

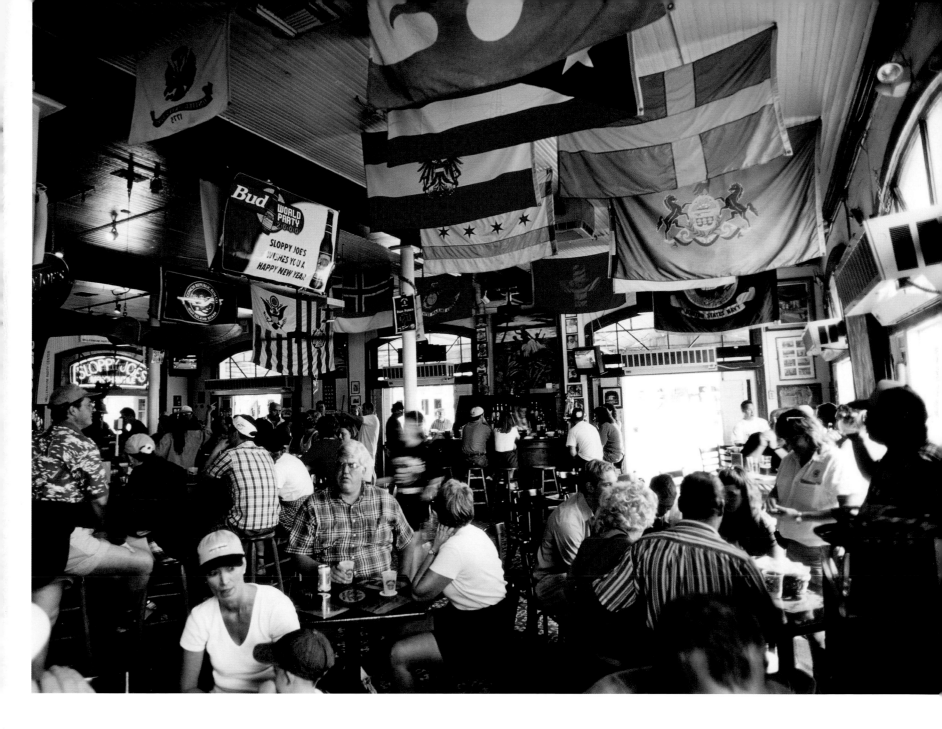

Sloppy Joe's has welcomed locals and visitors since December 5, 1933, the day Prohibition was repealed. The building is a landmark on Duval Street, the most famous thoroughfare in Key West. Ernest Hemingway, a patron of what was first called Russell's Bar, encouraged the name change to Sloppy Joe's.

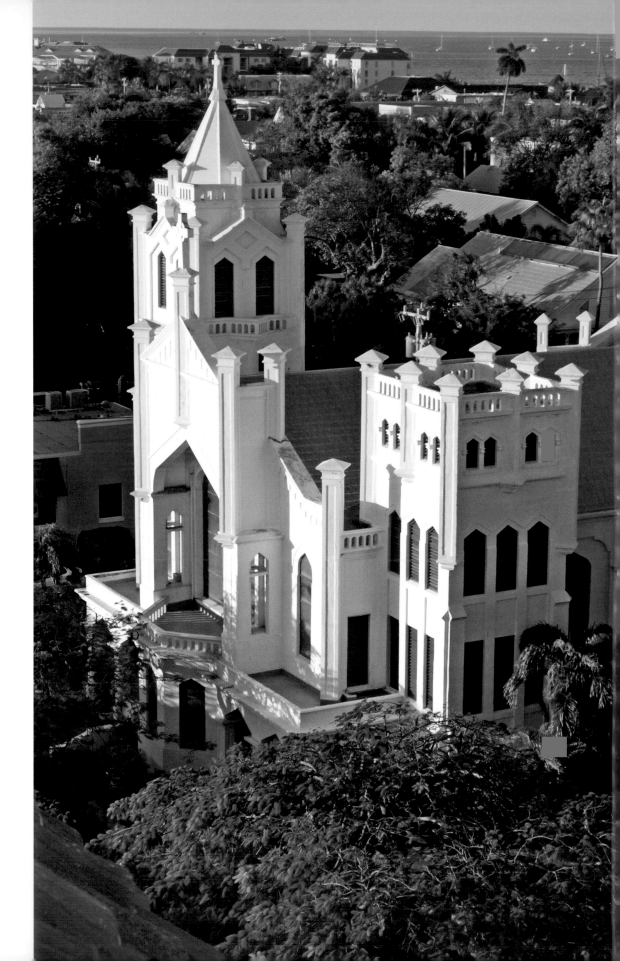

This late afternoon view is from the highest point in Key West. In the foreground rise the beautiful white towers of St. Paul's. First established in 1831, the church has withstood fires, hurricanes and other disasters, continuing as a landmark and place of worship for the community.

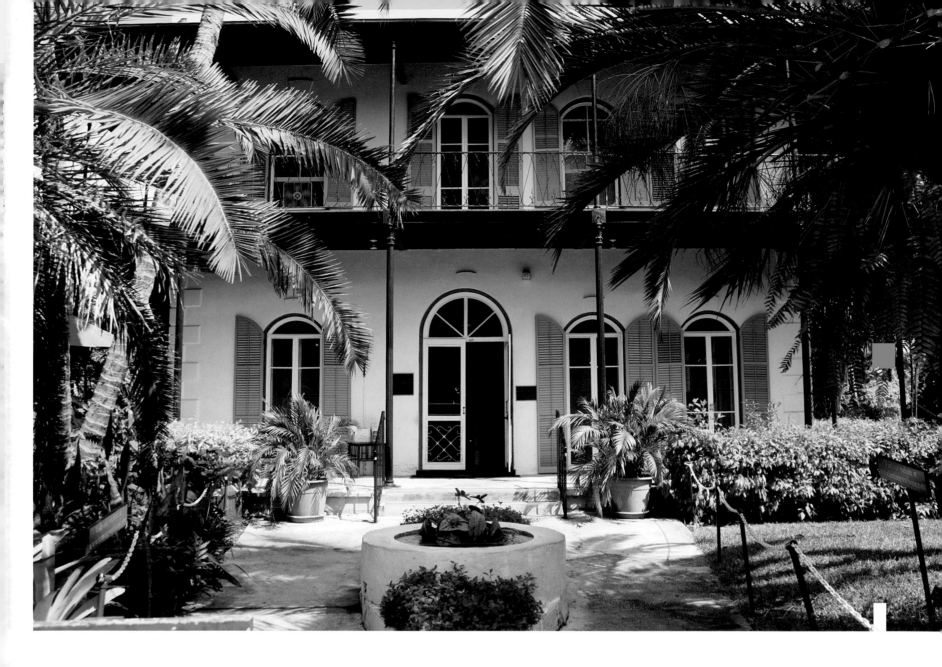

Ernest Hemingway's Key West home was built in 1851 for a marine architect. The author moved in 80 years later and began developing it to his tastes. The house contains Hemingway's furniture and was designated a U.S. National Historic Site in 1968. The numerous cats that wander the grounds are descendants of those kept by Hemingway.

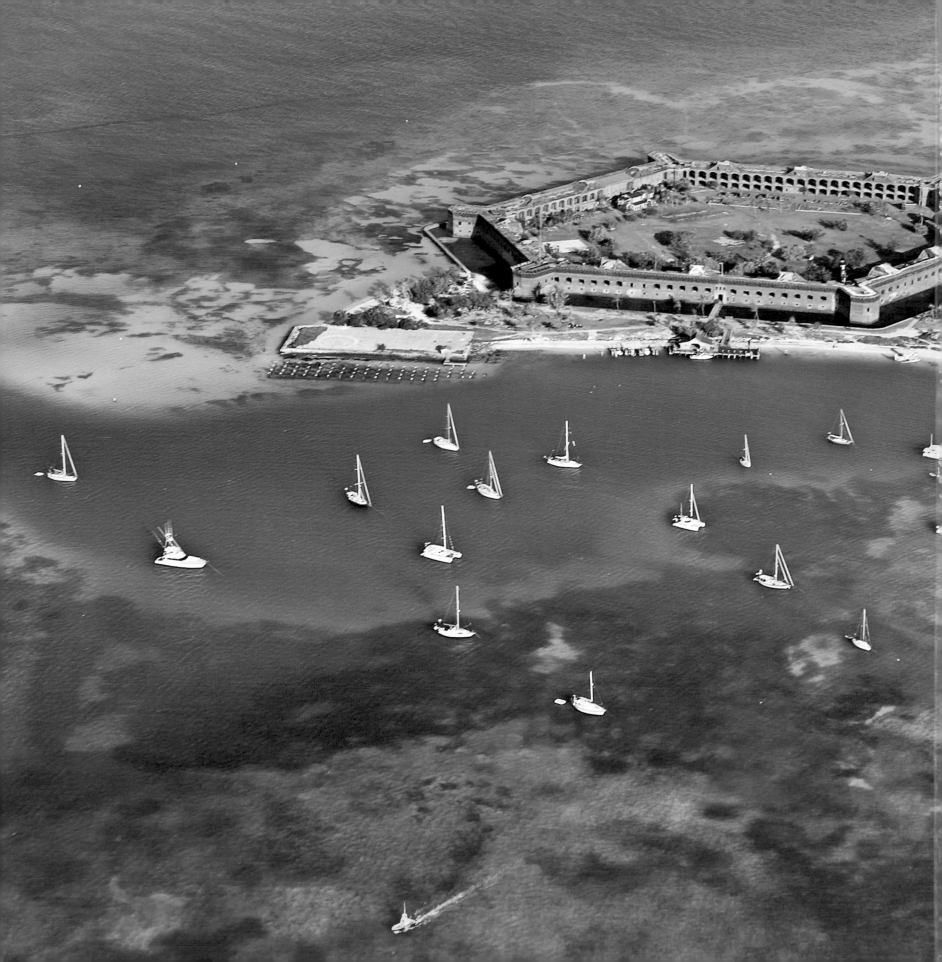

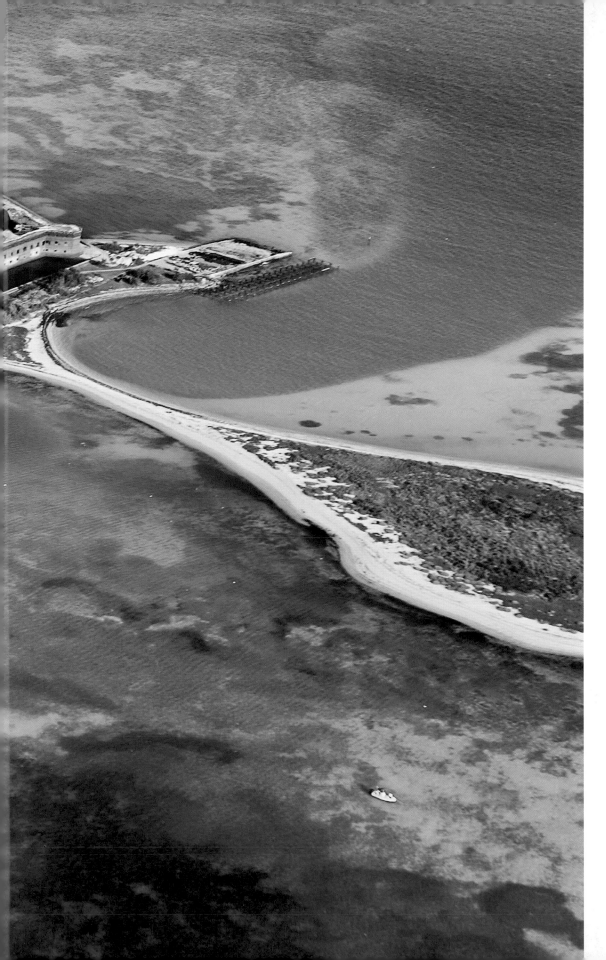

Dry Tortugas National Park is one of the nation's smallest, most remote and least-visited, yet the adventurous visitor is never disappointed. The area was named after the enormous sea turtles that Ponce de Leon, who visited in 1513, caught in the waters here. Work began on Fort Jefferson in 1846 and continued for more than 30 years but was never completed, since evolving military technology made the fort obsolete.

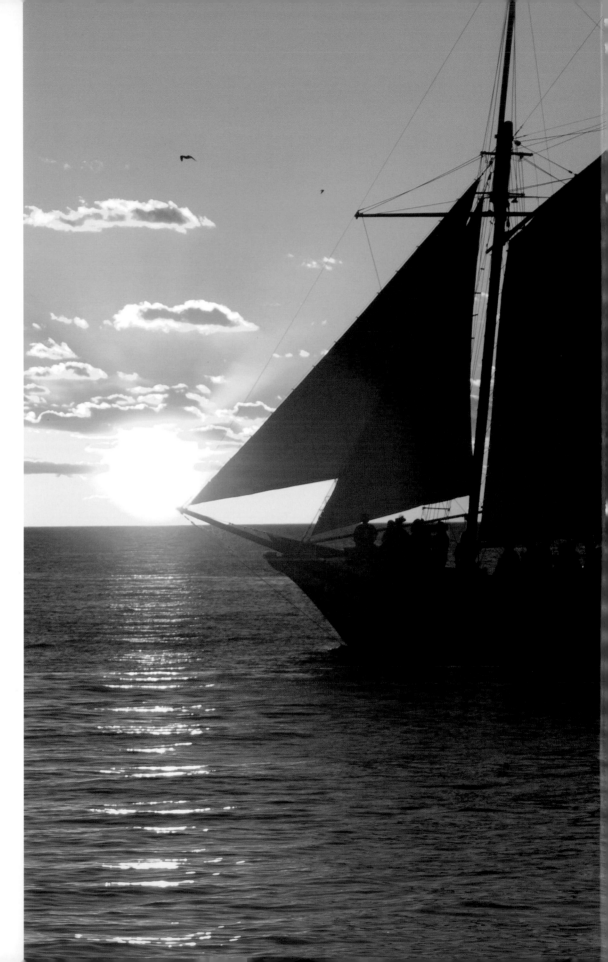

FLORIDA – PHOTO CREDITS

GETTY IMAGES
Altrendo Travel 93; Angelo Cavalli 82;
Cameron Davidson 29; Getty Images 42, 81;
Farrell Grehan 3(lower), 64; ISC Archives via
Getty Images 32; Adam Jones 4; L. Toshio
Kishiyama 45; Burton McNeely 19; John
Miller 90; Panoramic Images 10; Joe Raedle/
Staff 41; Sports Illustrated/Getty Images 80;
Mike Theiss 84, 87; US PGA Tour 24.

CORBIS
Atlantide Phototravel 68; Richard Bickel 18;
Franz Marc Frei 50; Raymond Gehman 8;
Blaine Harrington III 40; Karen Kasmauski
27; Raimund Koch cover; Bob Krist 91;
Richard T. Nowitz 48, 55, 79; Joseph Sohm/
Visions of America 5; Nik Wheeler 6, 9.

SHUTTERSTOCK
All images on back cover and jacket flap,
3 (top), 3 (middle), 7, 12, 13, 14, 15, 16, 20,
22, 26, 28, 30, 33, 34, 35, 36, 37, 38, 39, 43,
44, 46, 49, 51, 52, 54, 56, 57, 58, 60, 61, 62,
66, 67, 69, 70, 72, 74, 75, 76, 77, 78, 83, 85,
86, 88, 92, 94, 96.